CONTACT SHEET

NUMBER 122

THE LIGHT WORK ANNUAL 2003

CONTENTS

Light Work celebrates its 30th anniversary in August of 2003. For Phil Block and Tom Bryan, longevity was never part of the plan when they stepped in to run the new black-and-white photography darkroom facility, which Syracuse University constructed from a converted dining hall kitchen on campus.

The facility opened at a time when photography was coming into its own as a medium to advance social change, and as a means for personal expression. There were also enough fledgling photographers in Central New York to support a community access facility, and the lab was named Community Darkrooms. It became one of the country's most active public access photography labs, and a model for similar facilities across the country. There was no long-term plan beyond the demand for the facility, and Phil and Tom simply tried to match the programs and policies of the Darkrooms to the needs of the casual and serious users of the place.

A year later, Light Work was formed as a non-profit organization to raise funds from outside the university to support exhibitions, lectures, and workshops that would compliment the activity of the Darkrooms, as well as connect our local community with the ideas and practices of the larger art world. Sometimes simple plans are the best. After thirty years, the simple plan of meeting the needs of artists is still the guiding principle of Light Work and Community Darkrooms.

This annual issue of *Contact Sheet* includes work by all the artists who participated in our Artist-in-Residence program last year. For new subscribers to *Contact Sheet* who are unfamiliar with the program, we invite an average of twelve artists from around the world to participate in the program each year. Each artist is provided housing, a private darkroom, studio, or compute lab, and twenty-four-hour access to our facility, allowing them to focus on their work without distractions. At the end of their residency, each artist contributes a few prints to the Light Work Collection, and a selection of their work is published in this annual issue of *Contact Sheet*.

CONTACT SHEET 1
Community Darkrooms Light Work

First Glance

You are now reading the first issue of our new newsletter. We (the staff of Light Work/ Community Darkrooms) thought that this new format would make it a bit easier to keep in contact with you. We also knew that the mail-people of America would appreciate not having to tote so many one-shot announcements. And think of the barrels of printers' ink and acres of forest we'll save!

We don't have any plans to expand this newsletter into a regular periodical. Rather, we hope to put together an issue every six or eight weeks to keep you informed of new exhibitions in our gallery, photographers who will be coming to show their work, and those coming to spend time with us as artists-in-residence. And occaisionally, there may be an article with some hot air about art and life.

For your part, you can no longer count on reminders for each lecture date, etc. Please cut out the box of scheduled events that will come with each issue and nail it to your toaster. It's the best we can do. We do look forward to seeing you all at the photo-phestivities.

Color

COLOR PHOTOGRAPHY
Instructor: Peter Glendinning
MT evenings 6 pm. Five sessions
First section begins on Sept. 26
Second section begins on Oct. 24

Introduction to color printing using color negatives. Instruction in techniques and in color theory and perception. Previous experience in B/W is required.
Fee: $15 for CD members; $25 for all others.
Note: Chemistry and paper for color printing are each students responsibility. Be prepared to spend at least $30 for your materials.

Registration for these courses begins 9/9 at the Community Darkrooms.

Courses Offered

B&W

Community Darkrooms will offer the following non-credit courses this Fall. Each class has a limited enrollment, so early registration is suggested.

BASIC BLACK/WHITE PHOTOGRAPHY
Instructor: Lynn Mc Mahill
MWTh evenings: 6:30 - 8:00 for two weeks.
First section begins Sept. 26. This course is offered about ten times a year.

The basic course includes instruction in camera use, film developing, printing, retouching and matting of photographs. Students will learn how to do all their own processing. No previous experience is required, but a camera is necessary.
Fee: $30, which includes a 1 month mbrshp.

INTERMEDIATE BLACK/WHITE PHOTOGRAPHY I
Instructor: David Broda
Wed. evenings 6 - 8 pm; four sessions.
First section begins on Sept. 21
Second section begins on Oct. 19

Intermediate I is a "fine printing" course. Students will use one negative throughout this course and will learn advanced technique as well as archival processing, toning, presentation, sequencing etc. Knowledge of basic B/W is required.
Fee: $15 for CD members; $30 for others.

INTERMEDIATE BLACK/WHITE PHOTOGRAPHY II
Instructor: David Broda
Sat. mornings: 9 am to 12 noon.
First section begins Oct.1 Four sessions.
Second section begins Oct. 29 " "

Intermediate II explores the photographic negative. Instruction in seeing, exposure, development, lighting and other steps to produce quality negatives. Exercises to standardize your processes through film speed tests, development tests and use of the zone system. Previous knowledge of B/W processes is required.
Fee: $15 for CD membrs. $30 for all others.

Poems

Michael Jennings will give a reading of poems to accompany Dorothea Lange photographs on October 2 at the Everson Museum. Please call the Everson (474-6064) to find out what time Jennings' reading will be.

Photo-phestivities

DeCarava
Fri, Sept.16

Mertin
Thur, Sept.29

Banasiak
Thur, Oct.6

Riss
Thur, Oct.13

Since beginning in 1976, over 200 artists have participated in the program, and we have over 2,000 photographs in our permanent collection.

You will be able to find much more information about our residency program, as well as view all of the work in our collection through a searchable database on our Web site at <www.lightwork.org>. The site was recently redesigned by Sean Hovendick from Studio Fusion in Syracuse, and includes many new features including an on-line store where past issues of *Contact Sheet* may be purchased, along with a wide selection of original, signed prints by past Artists-in-Residence. Signed first edition books featured in previous subscription programs are also available on-line. We plan to update our new Web site often, so plan to visit on a regular basis to keep up with our current programs and special offers on books and prints.

In the 25th anniversary issue of *Contact Sheet*, published in 1998, I wrote an essay titled "Many Hands." It was a play off of the phrase, "Many hands make light work," and was an acknowledgement to all of the staff, artists, volunteers, bene-factors, and contributors that make Light Work, well, work.

We continue to expand on that practice in this issue, which features essays written by a number of contributors from around the world. Just as *Contact Sheet* is a venue to present new work by artists working in photography, we would also like it to become a venue for writers to express their ideas about the work being produced in our residency program.

The staff at Light Work has about as much longevity and experience as any artist-run arts organization around. Among the current staff are nearly fifty years of combined service, so when we have a change in personnel it is a marked occasion. This year, our archivist and data manager, Marianne Stavenhagen, left for the more temperate climate of Houston, TX. We wish her all the best as she pursues her educational and personal goals, and we thank her for many years of great service. In turn, we welcome Anisha Joseph, who assumes the new title of promotions coordinator at Light Work. She will be working on a variety of projects including managing data from the *Contact Sheet* subscription program, handling exhibit and program promotions, as well the editorial aspects of all our written communications, including *Contact Sheet*.

So that's all the good news, and indeed it is good news that a small, artist-run organization cannot only stay in business, but can continue to make a significant difference in the lives of artists. We have weathered a lot in the past thirty years, and have managed to thrive by responding to the needs of artists, and by fostering a community and an audience for their work. While we do not have any special plans to celebrate our 30th anniversary, we will continue to extend the many hands that, indeed, make Light Work.

Jeffrey Hoone
Director
Light Work

In the series *Hocus Pocus*, Judy Natal continues her ongoing visual investigation of letterforms, calling to mind the alphabet's magical history, and its participation in occult practices and contemporary signage in places dependent on illusion, such as Las Vegas. Natal's photographs become a stage show where tricks may be played to deceive the viewer, or through a sleight of hand and the incantation of a few precisely ordered letters, something startlingly truthful emerges.

The stage in these photographs, a small, but highly controlled field, is a square of saturated colors floating in a dark space, devoid of context. Light and shadow direct, and as in a magic trick, sometimes misdirect the viewer's attention. Often a layer of fabric hides something from our gaze, which is at times manipulated to shift attention from what is plainly visible. This magic trope calls up a whole tradition of the image's status as dangerous, having power to deceive, and at the very least, distracting attention from what is important—the word.

In these photographs, curtains often assist Natal's magic act and her concern with artfulness. The subtle cleverness of curtains pulled aside as in a Vermeer painting, is theatrical. It transforms the ordinary into a spectacular display. A curtain opens on a silver pitcher filled with flowers, suggesting a detail from the seventeenth century painting *Still Life with Flowers, Goblet, Dried Fruit, and Pretzels* by Dutch artist Clara Peeters. The traditional significance of still life is that it is a poignant reminder of the transience of life. Its appearance here points up the artifice of such symbolic transformations. The drama of the vanitas theme maintains its historical heft, but the sliver of a neon letter curving at the back of the space makes one somewhat uncomfortably aware of how dependent it is on a rigidly defined code. Natal's is not a harsh critique, but a subtle revelation, like the glow emitted by the letter beneath a soft green curtain, illuminating and activating the space.

Another image restages a mysterious seventeenth century Spanish painting by Juan Sanchez Cotan, *Still Life with Quince, Cabbage, Melon, and Cucumber*, again raising questions of artifice. A brilliant trompe l'oeil full of a precise attention to detail, the image retains the ambiguities of Sanchez Cotan. Natal furthers the uncertainty of meaning by suspending a neon "Y" in the composition of ordinary fruits and vegetables.

There is no visible curtain in this image. All is in plain sight. Yet, even the powerful white glow emitted by the letter does little to dispel the viewer's hermetic experience of this image. However, coupled with another image in the series, the photograph begins to reveal its meaning as letterforms do—as parts of a system of signification, rather than isolated signs. Here, the curtain itself becomes an explicit subject, taking the shape of a letterform. Fabric falls from two suspended points to form the letter "M" centered in a glowing space. It is not what lies behind the curtain, but the veil itself that Natal invites the viewer to contemplate.

Seen as a system, these photographs become a meditation on the history of visual practices and their relation to the perceived reliability of written language. The "hocus pocus" may lie in the way these images refuse to acquiesce to a simple binary opposition of image and text. Language, in the form of letters, always enters into the performance as in the case of the neon letter "G" which appears alone, almost fully revealed behind a grayish blue curtain. There are no flowers or vegetables, no historical references to still life or trompe l'oeil, only a letter. A letter, however, is never simply itself. By its very presence the "G" conjures up all the rest of the alphabet, reminding the viewer that the alphabet—invented more than 4,000 years ago—is invested with magical powers as strong as those associated with imagery. A disarmingly simple technology that can be mastered even by children, the alphabet is as tricky as any image.

This image of the letter "G" apparently even undermined Natal's own sense of *Hocus Pocus*, which she had thought complete. Now she realizes this is merely the beginning of an extended series of photographs. Even these few fragments train the eye to question what is shown, what remains hidden, and the magical illusions and revelations of image and text.

Debra Parr

Judy Natal lives in Chicago, IL, and participated in Light Work's Artist-in-Residence program in August 2002.

Debra Parr lives in Chicago, IL, and is a professor of art history at Columbia College, Chicago.

JUDY NATAL

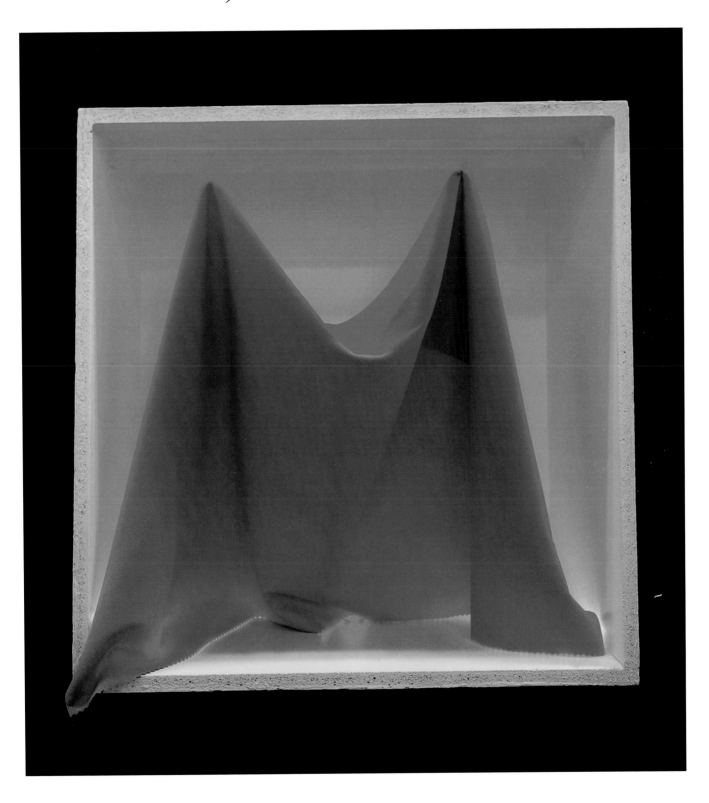

All images are *Untitled*, from the series *Hocus Pocus, 2002*
Chromogenic print, 8 × 8"

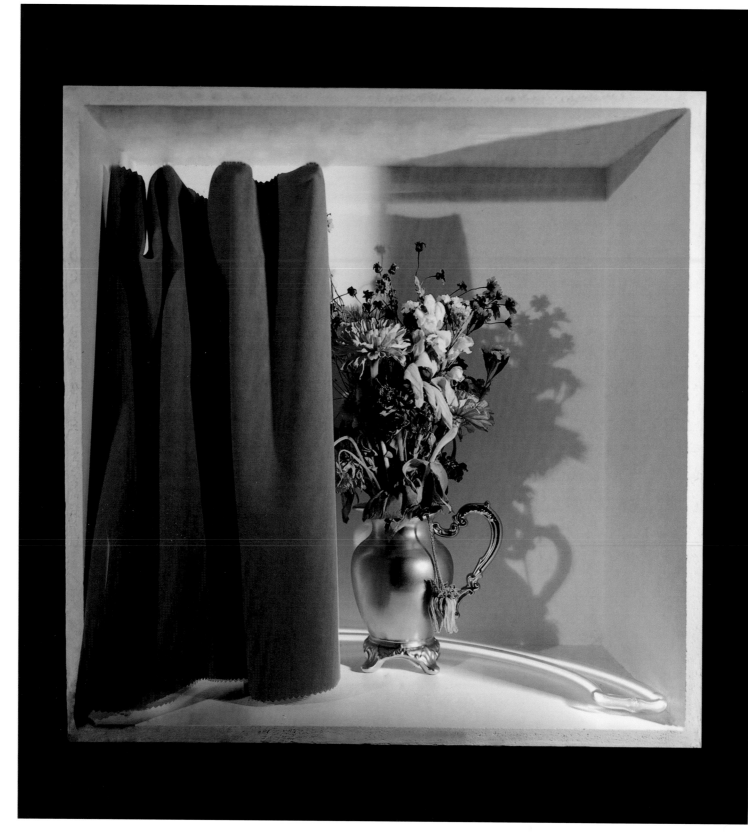

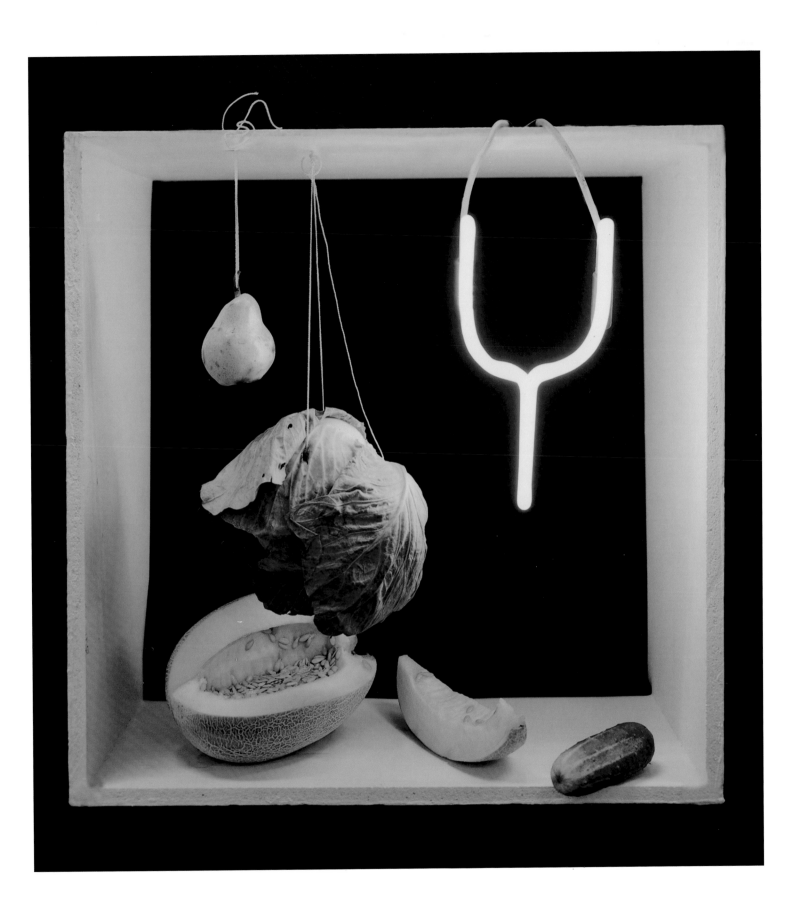

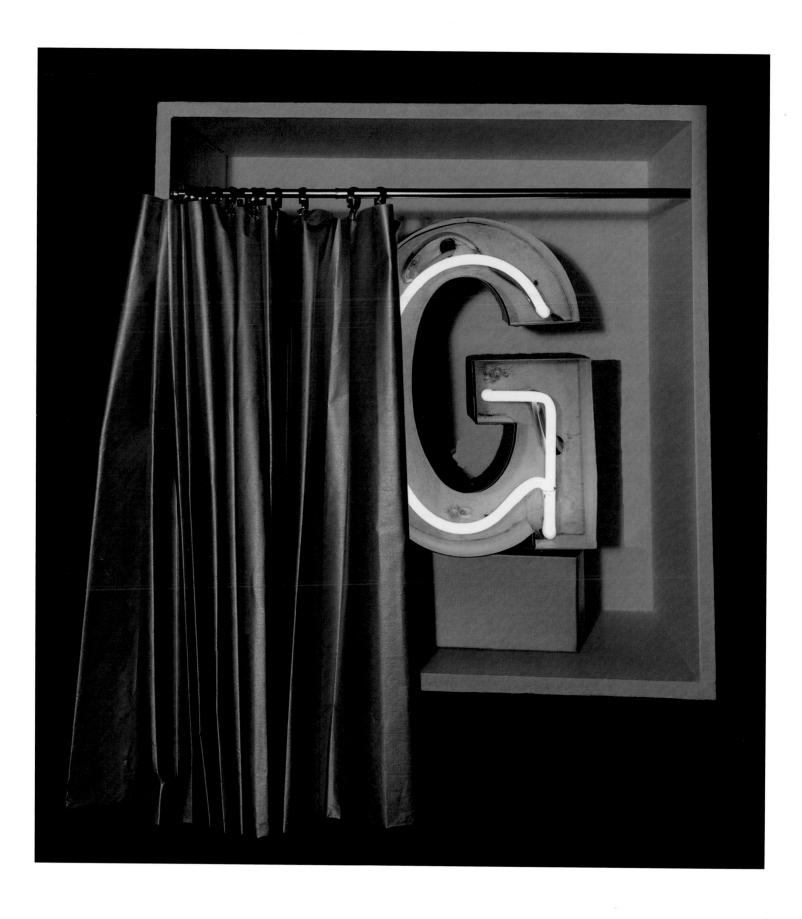

In October of 2002, Pamela So traveled from Scotland to start her Light Work residency in Syracuse, NY. It was her intent to examine American identity from the vantage point of being an outsider looking in. She decided to focus on using the representational power of the popular doll, Barbie. The result, embodied in the photographic series *Barbie as Tatiana*, explores the transgressive, recuperative possibility inherent in this most commodified of exports.

For over forty years, Barbie has perpetuated the myth of the American dream, sold to girls all around the world. Today, for young global consumers, she represents the single, unified, perfect image of American beauty. It is her white, anatomically impossible body and brash consumerism that they aspire to. Previous feminist critiques of Barbie being a global homogenizing force that commercially exploits a sexist body image must be re-evaluated.

Barbie as Tatiana toys with the tension between a globally recognized American icon and a distinctive local identity. The idea for Tatiana, the Russian waitress, originates from Little Odessa in Brooklyn, NY. The artist wishes to describe the unreality of this immigrant enclave and the contrary power it presents in what it means to be American today. She uses bright light and highly saturated colors to create photographs that resemble film stills from classic Hollywood cinema, the most seen and exported images of America.

Employing the advanced technology and equipment at Light Work, So produces a collection of photographs depicting an almost unreal suburban landscape in New York: sidewalk tables of the Tatiana Café, Brighton Beach and the Ferris wheel in the harsh autumn sun. Everywhere, Barbie's toothsome smile prevails and graces her milieu like a star. Stumbling upon a film set, the artist recreates the fantasy of Tatiana walking confidently into the technicolored mise-en-scène, probably into the making of another television or cinematic product bound for global consumption. The immigrant's identity is signified through stereotypical Russian decors, eclipsed by the all encompassing and perfect surroundings. The photographs force the viewers to question whether a working class immigrant waitress can be just as representative as the all-American girl, Barbie, and what an area like Little Odessa means in today's world order.

The series reveals something paradoxical in the hyper-real quality of the American urban landscape and of Barbie as a twentieth century icon. Barbie's perfect, unachievable beauty is the epitome of the unreal. Her body is so out of proportion that someone with the same physicality would not be able to stand up. As such, Barbie, seemingly oozing bodily perfection, is in fact devoid of sexuality—a plastic mould. Part of So's inspiration for the photographic series comes from the many images of women in the media who look like Barbie dolls. Thus, she begins to search for the real women behind the masks of mediated pictures of physical perfection. Barbie is shown to be no more, and no less, a masquerade than the hyper-reality that has permeated our world today. As Burgin asks, "How, unconsciously, is a sense of history and identity derived from the environment of media images?"[1] So's views of America have been those derived almost entirely from global media. Hence, through *Barbie as Tatiana*, she questions the contemporary image of the United States to the rest of the world, veiled behind media representation and commodities.

So's creative search for her own place as a resident artist in Syracuse, and as a Scottish-Chinese woman in the United States, is displaced onto the most commodified of all artifacts. The use of dress-up dolls as metaphors for contemporary identity ambiguity has always been a source of inspiration for the artist. In her previous art work, *Love and Abuse* (2000) and *Role Play* (2001), a Chinese doll performs the many facets of her mixed cultural references, focusing on the experiences in traversing identity boundaries. In this series, Barbie's consistent, timeless American self is employed to contrast with today's elusive and fluid subject positions. *Barbie as Tatiana* challenges the binary conditions: childhood/adulthood, American/non-American, global/local, and reality/unreality.

The series highlights the transgressive and redemptive quality in Barbie dressing down and passing for a menial worker. This all-American glamour girl, who is usually so devoid of political concerns, is forced to connect with class and identity politics. This may well be the most successful interventional tactic yet. *Barbie as Tatiana* whets an appetite for greater artistic truth, a process of rediscovering what lies behind contemporary global media and consumption.

Wing-Fai Leung

1. Burgin, Victor, *In/Different Spaces: Place and Memory in Visual Culture* (University of California Press, 1996), p. 211.

PAMELA SO

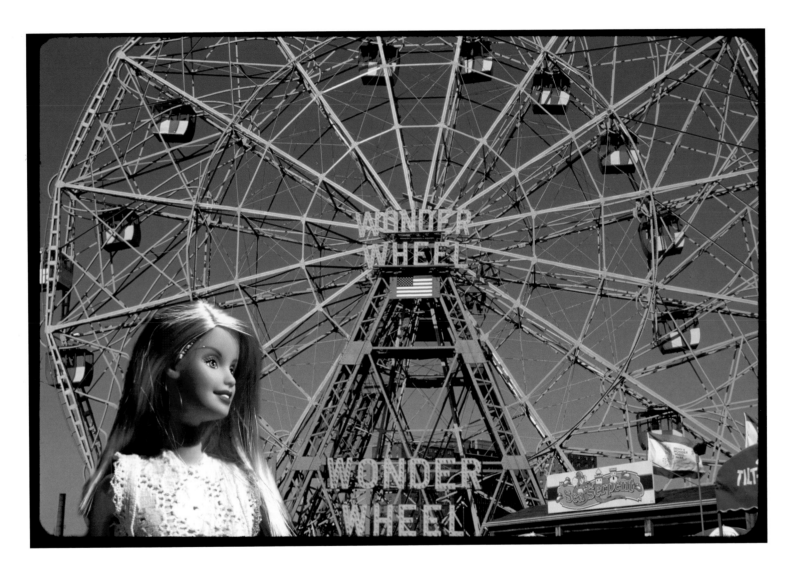

All images are *Untitled*, from the series *Barbie as Tatiana, 2002*
Inkjet prints, 16 x 20" each

Pamela So lives in North Ayrshire, Scotland, and participated in Light Work's Artist-in-Residence program in October 2002. Autograph: The Association of Black Photographers, located in London, made it possible for Pamela So to participate in the program.

Wing-Fai Leung is a PhD candidate at the School of Oriental and African Studies, University of London. She is the co-curator of Ten Thousand Li: Chinese In/fusion in Contemporary British Culture, *a national touring exhibition (2000-2003).*

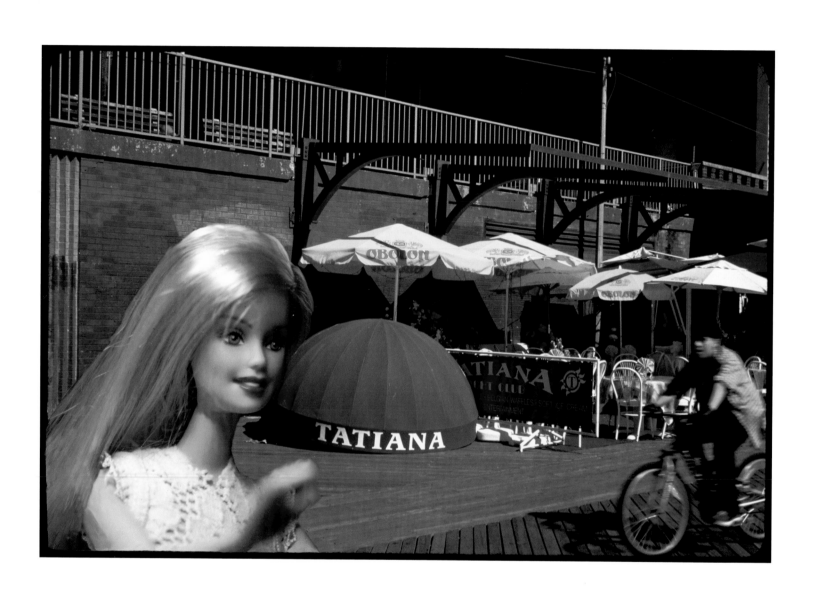

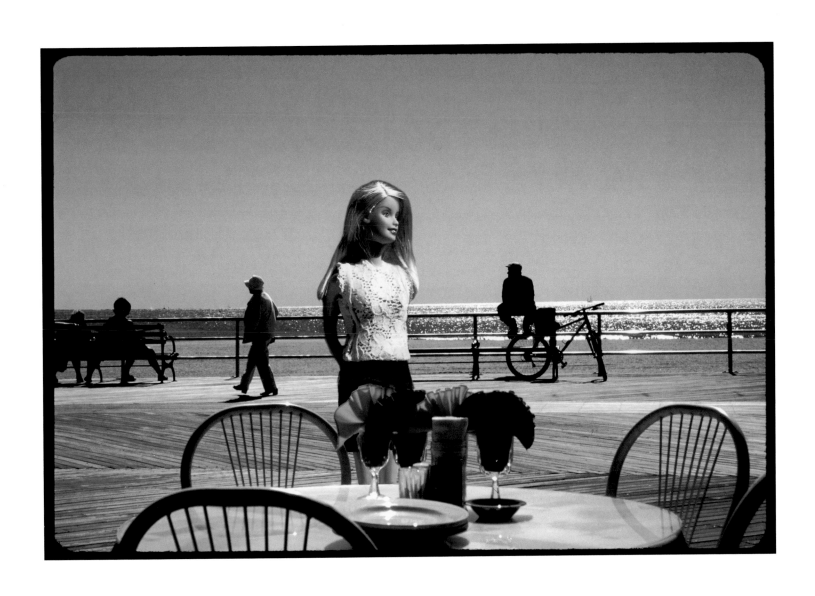

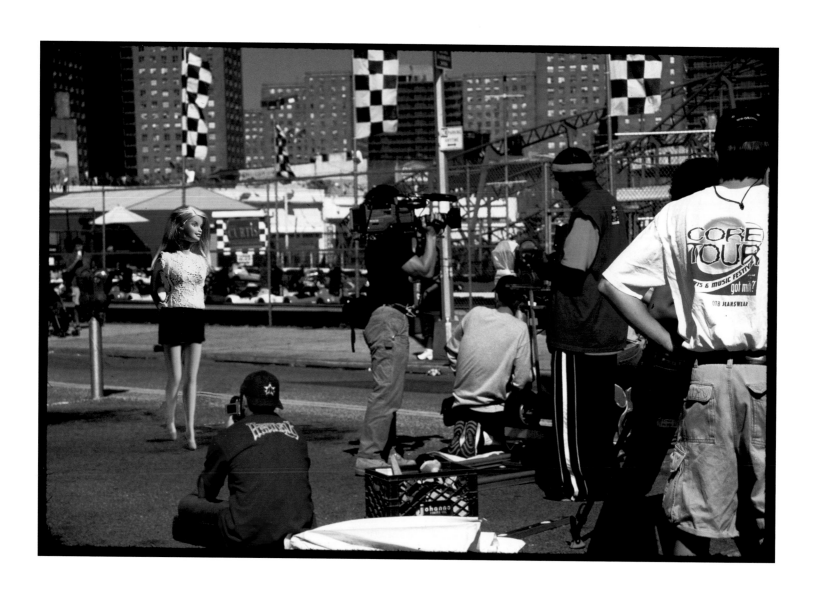

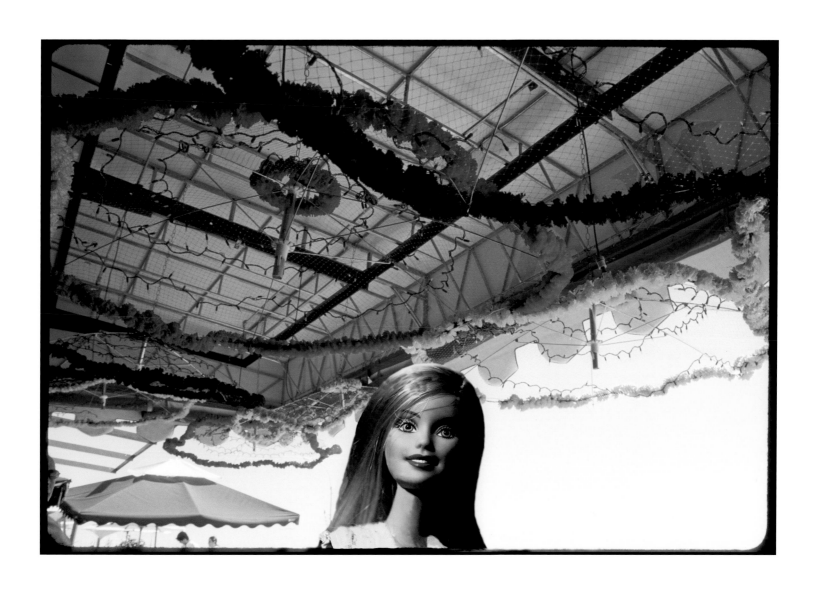

The animal has secrets which, unlike the secrets of caves, mountains, seas, are specifically addressed to man.

John Berger

Alessandra Sanguinetti has been unfolding a tale of animals and humans, and of their interaction and dependence. Set in the countryside within the province of Buenos Aires is an area known as Partido de Guido. Since 1996, she has been photographing this fragile terrain where the lives of the animals and the subsistence farmers share a practical and ritual space. The scenes are by local roadsides, fields and nearby woods where the farmers live and work, often within the property lines of the larger landowner.

Chickens, ducks, horses, pigs, geese, dogs, cows, lambs, cats, and rabbits populate these images. We see them as subjects caught in a dance of life and death, and at the service of those who raise and sacrifice them for food, or modest income. This is a countryside where past meets present, and where the relationship between the everyday and the mythical can be unveiled by careful and empathetic observation.

In describing this work Sanguinetti has said, "This project interprets the people and animals inhabiting the Pampas, their relationship with each other and the land. In the rural farmland of Argentina, this relationship is part of everyday life. Small and open land farming, unlike intensive and factory farming, has resulted in a language of traditions that persists over the years, where the cycle of life and death is present everyday, from dawn to dusk."

It is a mark of fables to endow animals with human qualities. Real and imaginary relations with animals disclose social conditions while offering messages or promises. Our memories include domestic pets that are "family," and the acts of heroism, gentleness, fear or cunning that each animal story embodies. While we live in parallel universes, in these images animals and humans double for each other. The animals stand (and fall) for us, and their significance derives from the ignorance of what has or will happen to them.

Sanguinetti's photographs make visible a dialectic of transcription and invention. Her work embraces the contemporary circumstances of documentary practice. It is committed to—but not restrained by—an obligation to represent truth. She discloses situations that invite the viewer to confirm the simultaneous appearance of natural, social, and symbolic phenomena.

The pictures of death and carcasses interrupt the sentimental imagination with a psychic violence, an unblinking acceptance that questions our position in the cycle. Many of the images are taken from the vantage point of the animals, placing the viewer up-close amongst them. Sanguinetti is acutely aware of the gaze of the animals, and how their looking at us is at once plaintive and wary. This interplay between scene and gaze can be haunting and unsettling. We are brought closer to the transformation from living beings to material substance.

Sanguinetti states, "To portray an animal is to name it. Once named it acquires a new life, and then, is spared death. Each sacrifice gives us back a disturbing image of the border we cross when we end a life, and what it means to turn another living creature into a source of food. It is possible that by exploring the fine line that separates us from what we rule, we may reach a better understanding of our own nature."

Returning over time to the surroundings of the farmhouse, the nearby lands and the sites of daily labor, the photographs indirectly chart a path to our notion of origin, home. Allegories of modern, post-industrial, urban society are silently thrown into relief. The images allow us to consider the implications of being seen by the animals as we look upon them. They provide the animals and the inhabitants with something their individual lives could not offer—that we remember them.

Robert Blake

Alessandra Sanguinetti divides her time between Buenos Aires and New York, NY. She participated in Light Work's Artist-in-Residence program from April 15 to May 15, 2002.

Robert Blake chairs the General Studies Program at the International Center of Photography in New York. He is co-founder of the performance group, Hybridaxe, produces photographic and video documentaries, and writes frequently on contemporary photography and art.

ALESSANDRA SANGUINETTI

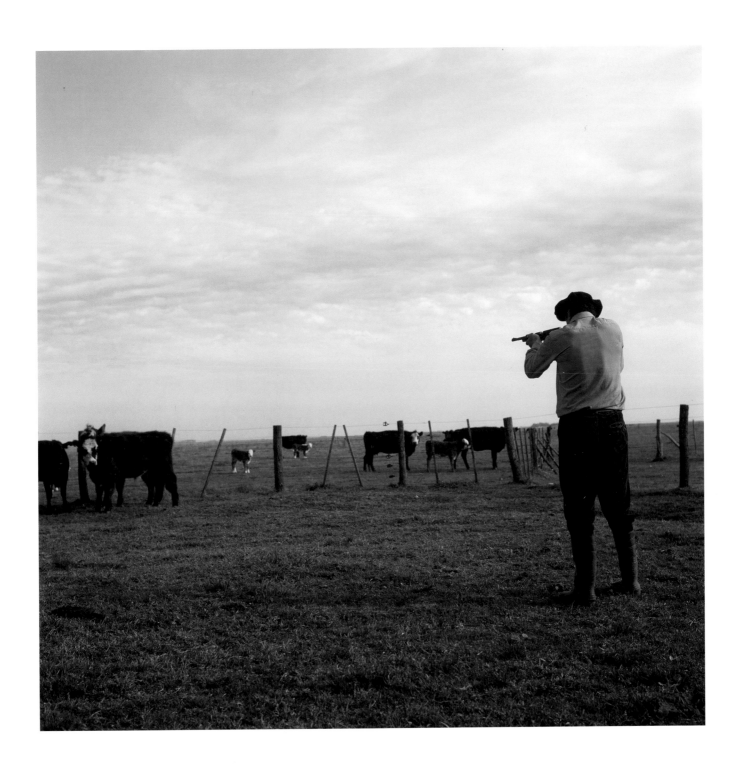

All images are *Untitled*, from the series *On the Sixth Day, 1996–2002*

Cibachrome prints, 30 × 30"

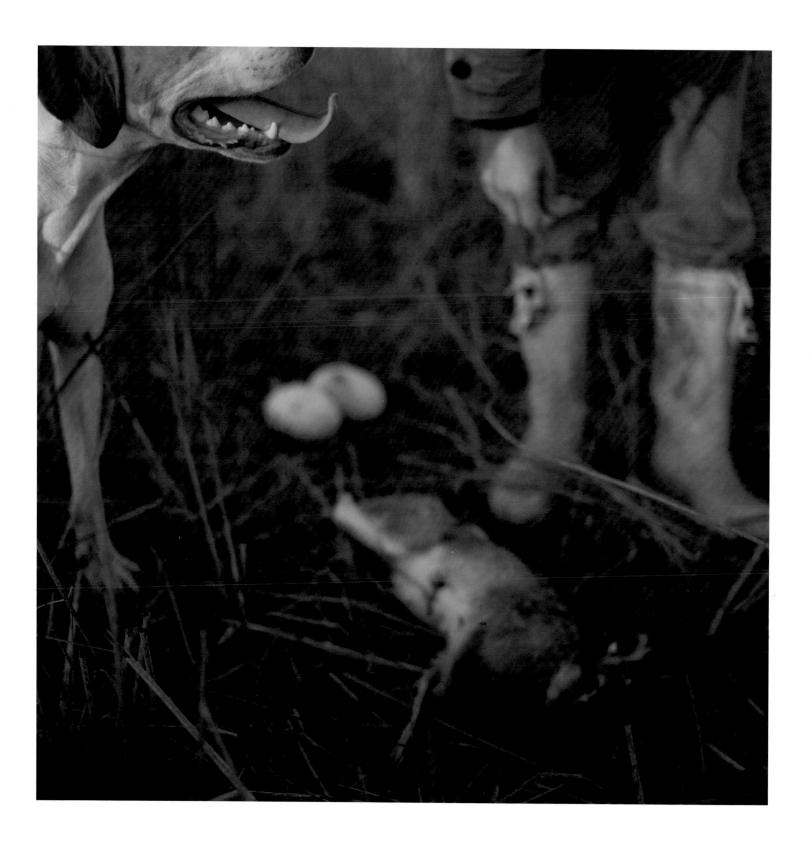

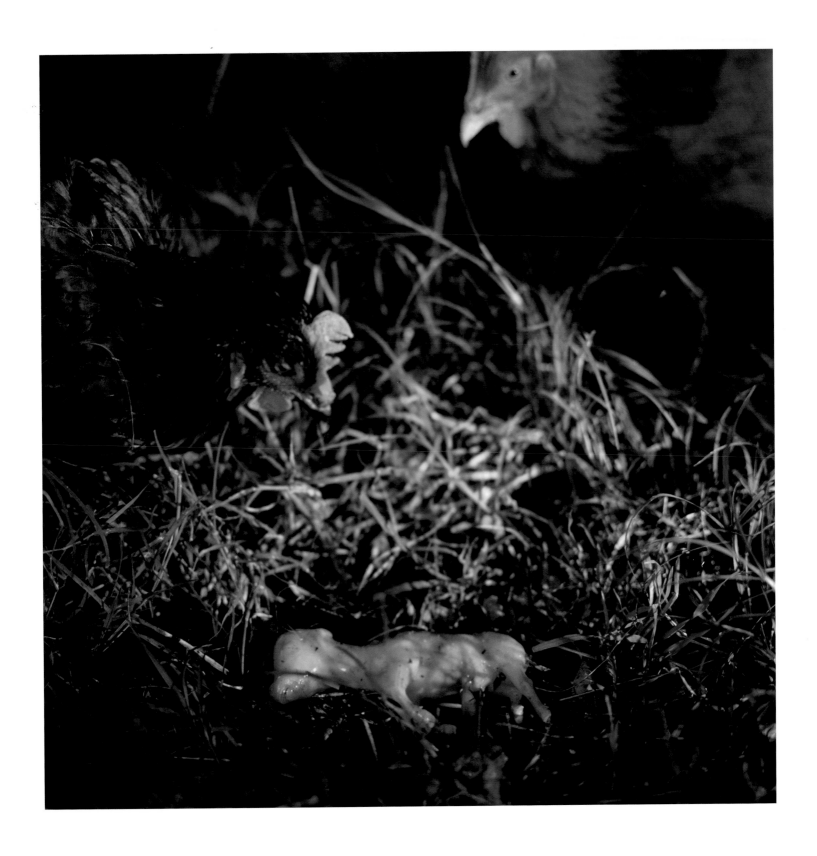

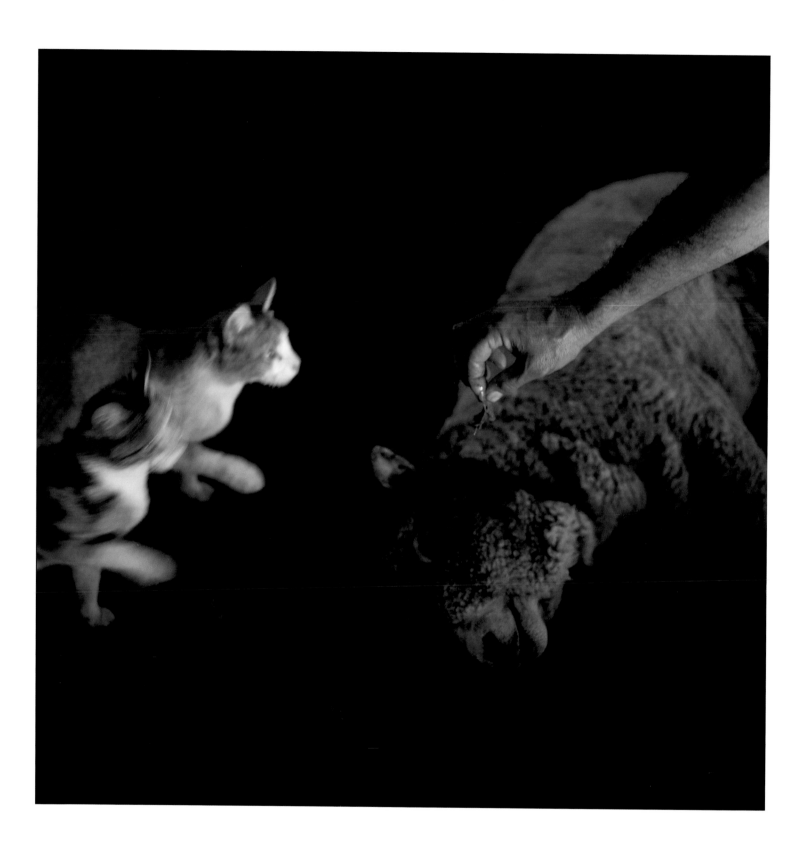

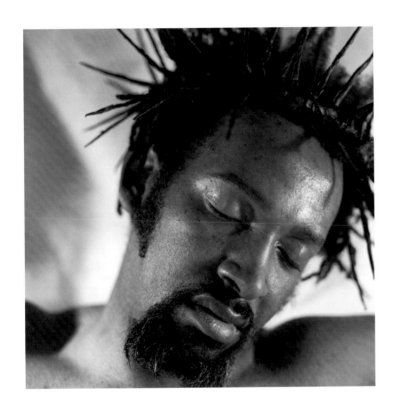 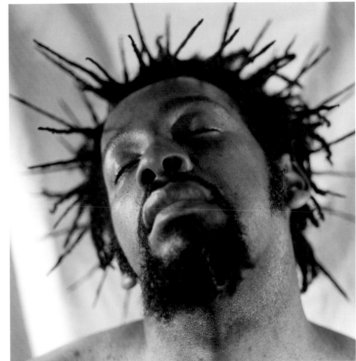

(left) *Woman, behold thy Son; Son, thy Mother,* 2002

(right) *My God, my God, why hast thou forsaken me?,* 2002

Pigmented inkjet prints, 20 × 20" each

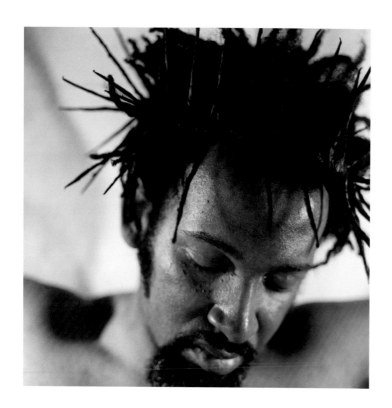
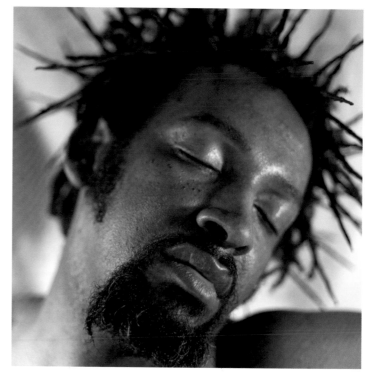

(left) I thirst, 2002
(right) Into thy hands I commend my spirit, 2002
Pigmented inkjet prints, 20 × 20" each

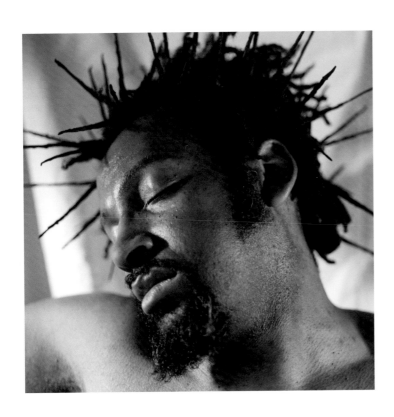

It is finished, 2002

Pigmented inkjet print, 20 × 20"

Ellen Blalock uses her artistic vision and the mediums of video and photography as expressions of her ideas as they relate to society and the issues that plague African-Americans in a predominantly white minority-run country. Blalock, given the gift of a rich and passionate history, allows the voices of her ancestors to resonate through her ideas and creativity. This series explores the human condition through the African-American experience, and strikes a chord in one's soul.

The *Father* series brings the teen father into focus. We read and hear about the impact of parenting on teen mothers, but what of the fathers? Father. The word, for many, means caretaker, protector, nurturer, parent, and unconditional love. But does the fact that one can spill sperm, or "shoot a load," mean they understand the full impact of fatherhood?

The struggles of young African-American men have grown to gargantuan proportions. For years, sociologists have studied the trends of teenagers having children, and the impact it has on their lives. Studies have shown that children born to children have less of a chance to succeed in life, and often repeat the cycle of the birth parent. In turn, social programs have been created to teach these teens how to meet the needs of a newborn baby.

Blalock, through her human-mechanical eye and empathetic soul, focuses on these man-boys with the product of their lust, youthful exuberance, recklessness, immaturity, and rite of passage from boys to men. She captures their words, voices, attitudes and expressions, hopes and dreams, and love for their children through video and photographs.

A scenario: A student in college, now working a minimum wage job trying to support his tiny princess, asks his employer for more hours.

Time passes, dreams fade, jobs lost, unskilled, but still trying. Will he stay? He hopes, they hope, we hope, but sometimes he can't see that, in this situation, dreams can fade even more quickly and harsher.

"I want to be just like my father. Yeah, my Father is in prison right now, but he's a good father. He's been in prison most of the time I was growing up, but, I love him...Yeah, I want to go to college for a couple of years...I want to be a doctor."

"Dawg. This is my Dawg," says one young man looking at his infant son with pride. He never sees a time when they will be apart. This is quite possibly the one person he can depend on to love him unconditionally.

These young men struggle to understand the responsibility of being a parent, and are disparaged by a society that fails to comprehend, or see them as young men; a society that asks, "What has any young man to offer a baby when they have not yet completed this part of life's journey?"

A teen father may deny a child parentage, not because he wants to, or because of lack of feeling for the child, but because he wonders: "How can I take care of 'this' when I cannot take care of myself?" This may be attributed to the social morals held by this culture where these young men are viewed as children. Historically, in other societies, mates are taken and households are set up when boys turn thirteen or fourteen. It is considered their rite of passage to becoming men. Procreation is reality.

However, society insists that the teen father cannot, or should not, be a part of the child's life, basing these decisions partially on an economic perspective. It fails to take into consideration that these young men do have the capacity to love and honor the gift of birth, and see this as a life-changing event.

The disparaging of teen fathers only serves to show a lack of respect for these young men and increases their inability to cope with an extremely difficult situation in life. The support that should be shown to them may help change the perceptions they have of themselves and their abilities, helping them to be a positive force in their babies' lives. Blalock's work allows these men to be heard. Her photographs resonate with the many stories and paths taken, and not taken, by teen fathers trying "to do the right thing."

Mark Wright

Ellen Blalock lived in Georgia before recently moving to Syracuse, NY. She participated in Light Work's Artist-in-Residence program in July 2002.

Mark Wright is a poet and playwright who lives in Syracuse, NY, and works for the Cultural Resources Council.

ELLEN BLALOCK

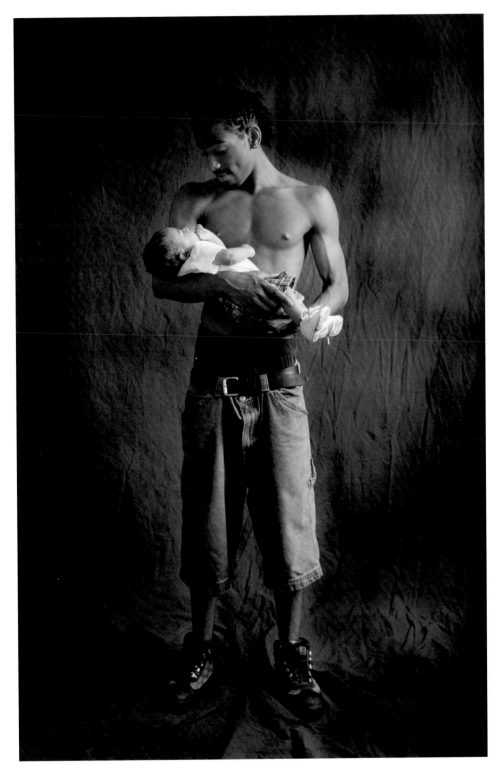

Skyler, 17 with son, Skyler Jr. 2 Months, 2002, from the *Father* series
Pigmented inkjet print, 15 x 9¾"

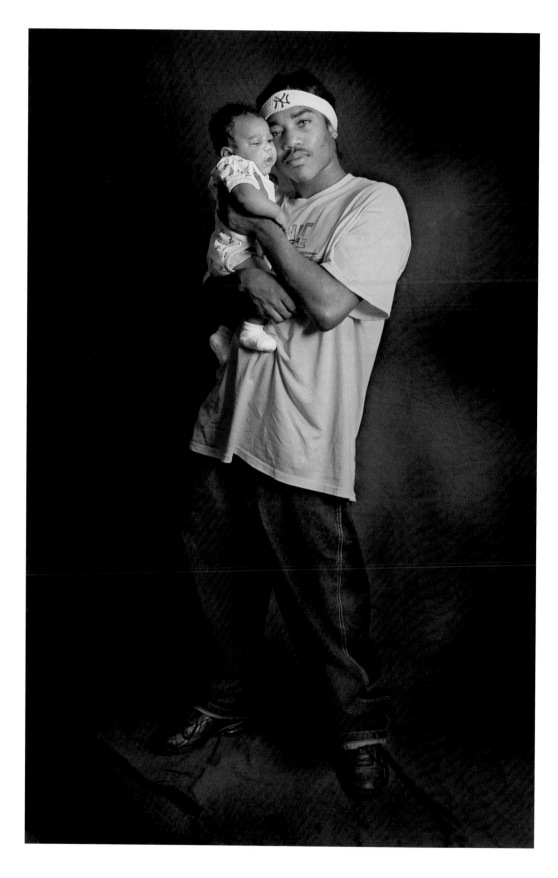

Raymond, 17 with son, Raymond Jr. 2 Months, 2002, from the *Father* series
Pigmented inkjet print, 15 × 9 3/4"

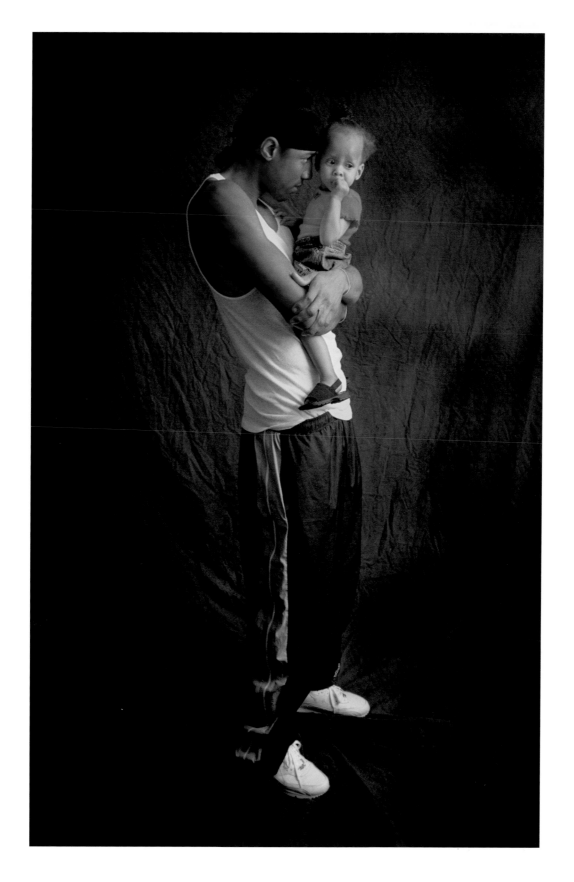

Jermane, 19 with daughter, Jada 11 Months, 2002, from the *Father* series
Pigmented inkjet print, 15 x 9¾"

Andrew, 26 with son, Tyshaw 8-years-old, 2002, from the *Father* series
Pigmented inkjet print, 15 x 9 3/4"

Figure A	Population change (mid-year to mid-year)[1]

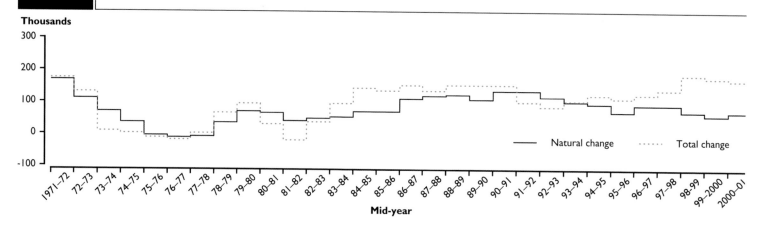

Offered here are eight observations that, like Rebecca Hackemann's boxes—or "optical sculptures" as the artist calls her works from her 2002 residency at Light Work—can be approached individually or read successively:

1. Lying alongside the works rather than laying claim to them, the observations foreground this central motif: The construction of a view, its counterpart, and the distension of the pair in a chain of variations. As the fluttering wings depicted in *The Independent Wing!* suggest, movement around Hackemann's works is crucial. Privileging no single viewpoint, they also refuse a single account.

2. Evenly spaced and wall-mounted, her works resemble minimalist objects. Their horizontal span accentuates the architectural frame, while the matte white surfaces subtly register the immediacies of light. Yet lenses embedded in their sides open onto stereoscopic images. Just as the pregnant angel in *The Revolt of the Angels* is both mother and child, container and contained, the sculptures cater to two viewing distances—far and near—alternately bleeding into their context or presenting private, interior worlds.

3. Simultaneously and respectively channeling each eye towards slightly different photographs, the stereoscope eliminates the single viewpoint assured by monocular perspective. As Jonathan Crary has noted, the stereo image offers "an assemblage of local zones of three-dimensionality [that] never coalesce into a homogeneous field." Visually fragmented, the resulting composite's effect is theatrical. Indeed, early Wheatstone stereoscopes employed angled mirrors to reflect photographs held parallel to the line of vision—mirrors to which *The Progress* appropriately adds a crystalline cloud of smoke.

4. In lodging vision within the subject, the stereoscope disengages observer from object of vision. Similarly, while the female figure in *The Institute of Incoherent Geography* clasps a double-lensed apparatus to her eyes, apparently mirroring the stereoscopic observer, her sightline, in fact, pitches to the upper left. Fracturing monocular perspective's equation of eye and vanishing point, the offset axis voids the mutually affirmative reciprocity that once bound subject and object together in an immobile universe, heralding instead a geography that, as the title suggests, is insistently incoherent.

5. If Hackemann's stereoscopic images undermine the fixity of monocular perspective, the collective arrangement of the boxes simultaneously dismantles the disembodied eye of modernism. Not only reminiscent of minimalism's incorporation of the viewer's bodily movement, the ambient sound generated by other viewers recalls the approaching footsteps that interrupt Sartre's visual mastery through a keyhole and underscore his corporeality in *The Look*. Indeed, *The Unbearable Lightness of Being—An Intellectual* conjures less the lightness of the body distilled to its pure optical faculty than its inescapable heft.

6. Hackemann's concomitant reference to stereoscopy and minimalism is not accidental. Just as the former places the viewing subject in a fluid world of ceaselessly circulating commodities, so the latter replaces the art object with total design, reflecting the rapacious expansion of capitalism. In this regard, *The Turkey*, depicting a quasi-anthropological bird surrounded by theatrical props, is less disarmingly fictional than disturbingly portentous, describing as it does an objectified subject within a totally controlled environment.

7. Presenting two exemplars of corporate capitalism, *The HuMans* elaborates this cautionary tale. Despite their upright bearing, the suited figures are headless, devoid of visual and linguistic abilities alike—the defining features of the human. In contrast, Hackemann's works comprise precisely a combination of image and text. Indeed, the caption here specifically elaborates the centrality of language: "The reason they never mastered conversation wasn't because humans were too complex, but because they were so simple."

8. Hackemann draws from early nineteenth century physiology to late twentieth century art. With systematic consistency, the elements of her works demonstrate a commitment to maintaining multiple viewpoints—a commitment that is not merely theoretical, but has practical political consequences too. As the replacement of the notes in the first bar of *The Star-Spangled Banner* by blindfolded heads in *Oh, say! Can you see?* suggests this project is perhaps now more urgent than ever.

Christopher K. Ho

Rebecca Hackemann lives in New York, NY, and participated in Light Work's Artist-in-Residence program in July 2002.

Christopher K. Ho is a curator and art historian who divides his time between New York, NY and Providence, RI where he teaches at the Rhode Island School of Design.

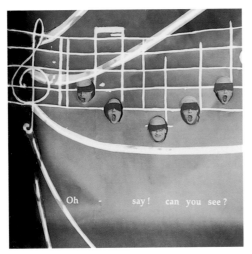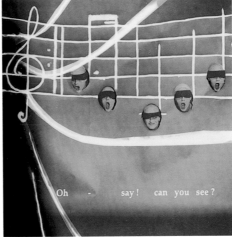

Oh say! Can you see?, 2002

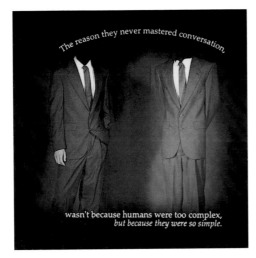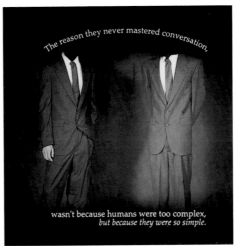

The HuMans, 2002

How does one photograph a memory? How does one document a relationship with the deceased? How does one photograph an adored daughter with objectivity? Osamu James Nakagawa asked himself these questions a few years ago after experiencing the death of his father and the birth of his daughter, both within a short period of time. He turned to family photographs and shadows as devices with rich expressive possibilities.

The title of the series is *Kai*, which translated means "cycle." Among the images in the series is *Kai, Ninomiya, Japan, Autumn 1998*, which depicts a large framed portrait of his father leaning against his wife's legs as she stands in an empty, watery landscape holding their daughter. Three generations are portrayed, but his father is present only in the frozen memory of the formal portrait, chosen by his family to be shown at his funeral. He similarly addresses generations in an image of his daughter playing, while his shadow is on the wall to her left and his wife's profile is projected on the wall to her right. In *Morning Light, Bloomington, Indiana, Spring 1999*, his daughter plays happily in the confines of this protective bracket. For the moment, she prefers a camera to the zoo of stuffed animals at her feet. Eventually, he and his wife will fade away, becoming shadows themselves. One hopes that the family cycle will continue to evolve with his children's children. Facing the mortality of a parent forces one to consider their own mortality.

Born in New York City in 1962, Nakagawa was seven months old when his Japanese-born parents took him and his older brother back to Japan. Fifteen years later, the family returned to the United States where he attended high school in Houston. His parents subsequently returned to Japan while he stayed in the United States to continue his undergraduate studies at the University of St. Thomas and graduate studies at the University of Houston. He returns to Japan periodically, some visits lasting up to a year.

Having been first exposed to photography through the esteemed work of his uncle, Takayuki Ogawa, Nakagawa has, from the beginning of his education, blended interests in cameras, computers, and the disparities of his dual cultural upbringing. As a recent press release stated, "The cross-cultural experience of being neither a stranger, nor a native, of either Japan or America informs the content of his artwork to a large extent."

Nakagawa's earlier work, the *Billboard* series, imposes images of minority cultures in the United States on billboards and drive-in movie screens. In the most widely reproduced image from the series, a face in a gas mask looms over an urban roadside. This image brings a chilling relevance as threats of war and terrorism are woven more tightly into the fabric of American life.

Using materials and images inherited from his father, Nakagawa is shifting toward the exploration of his Japanese roots, as well as to the variances in documented and remembered pasts. In light of the cross-cultural tensions that are constant in his life, he reconsiders his past, as well as the past of the two nations of his heritage. Ever since U.S. Navy Commodore Perry's black ships sailed into Nagasaki's harbor in 1853, forcing Japan to open itself to foreigners after over 200 years of isolation, U.S.–Japanese relations have coexisted in a blend of conflict and productivity.

Nakagawa's new series is titled *Ma–between the past*. The translated meaning of *Ma* is "that which is between, in the gap." In this series, photographs taken by his father and maternal and paternal grandfathers, trigger Nakagawa's memories of the past. He then combines their images with photographs he took in Japan and the United States. With the aid of computer manipulation they collapse time and place, much as our memories often unite people and places that never coexisted in the real world. The images are between cultures, between generations, and between time.

A glance at Nakagawa's work may suggest that the images are documentary in nature. But whether an image is "straight" or computer enhanced, on more careful study, the straight narrative approach shifts to a less easily explained layered meaning. He combines people, objects, and landscapes more like a poet than an essayist. Just as he straddles two cultures, his images are neither clear nor certain in fecund ways.

Anne Wilkes Tucker

Osamu James Nakagawa lives in Bloomington, IN, and participated in Light Work's Artist-in-Residence program in June 2002.

Anne Wilkes Tucker lives in Texas, and is the Gus and Lydall Wortham Curator of Photography at the Museum of Fine Arts in Houston.

OSAMU JAMES NAKAGAWA

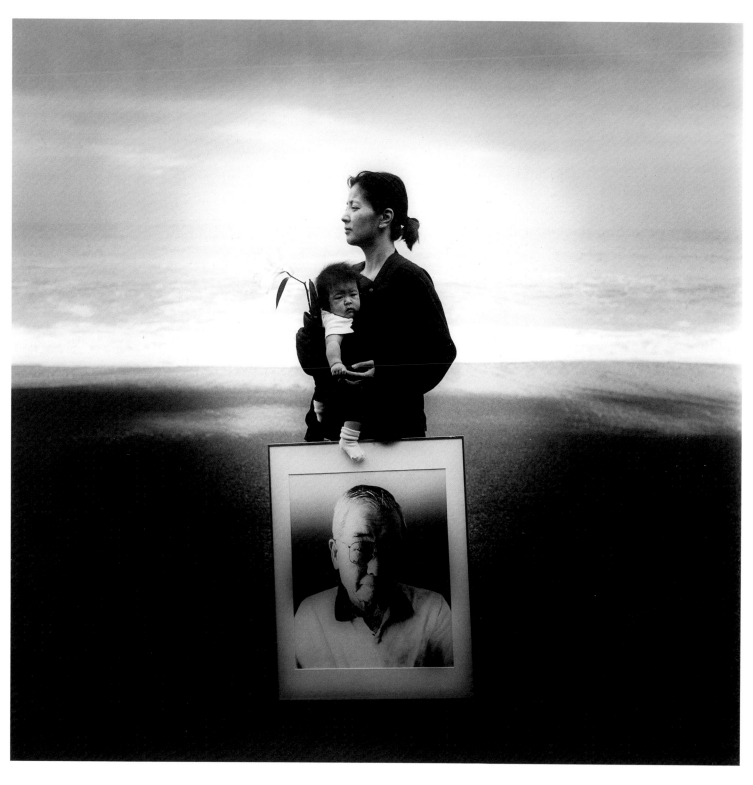

Kai, Ninomiya, Japan, Autumn, 1998
Silver gelatin print, 14 x 14"

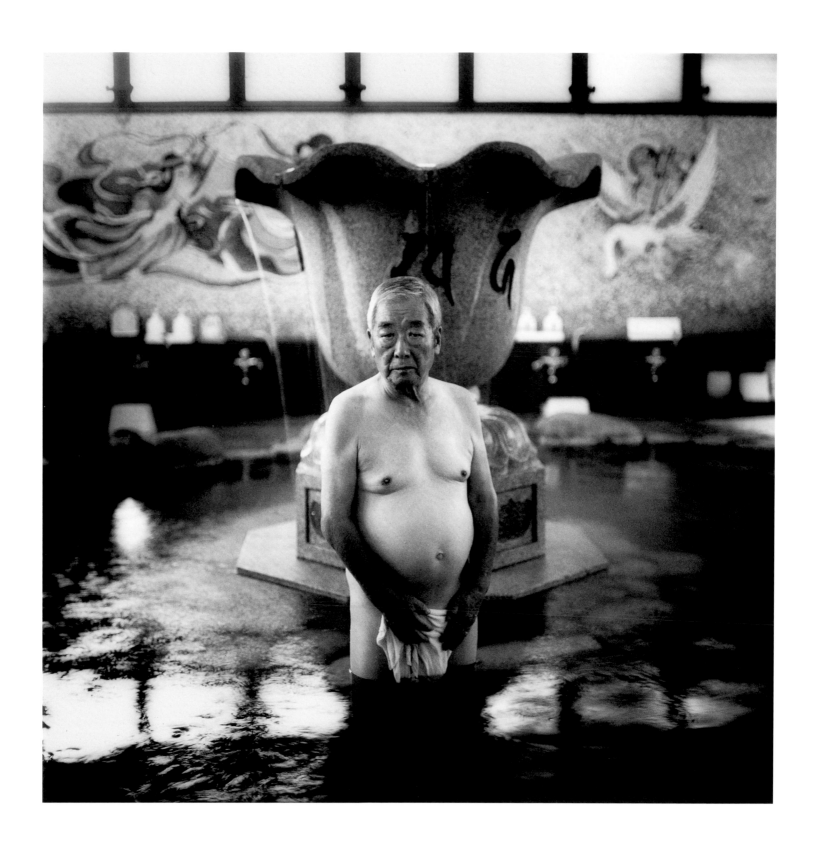

Hot Springs, Hakone, Japan, Summer, 1998
Silver gelatin print, 14 x 14"

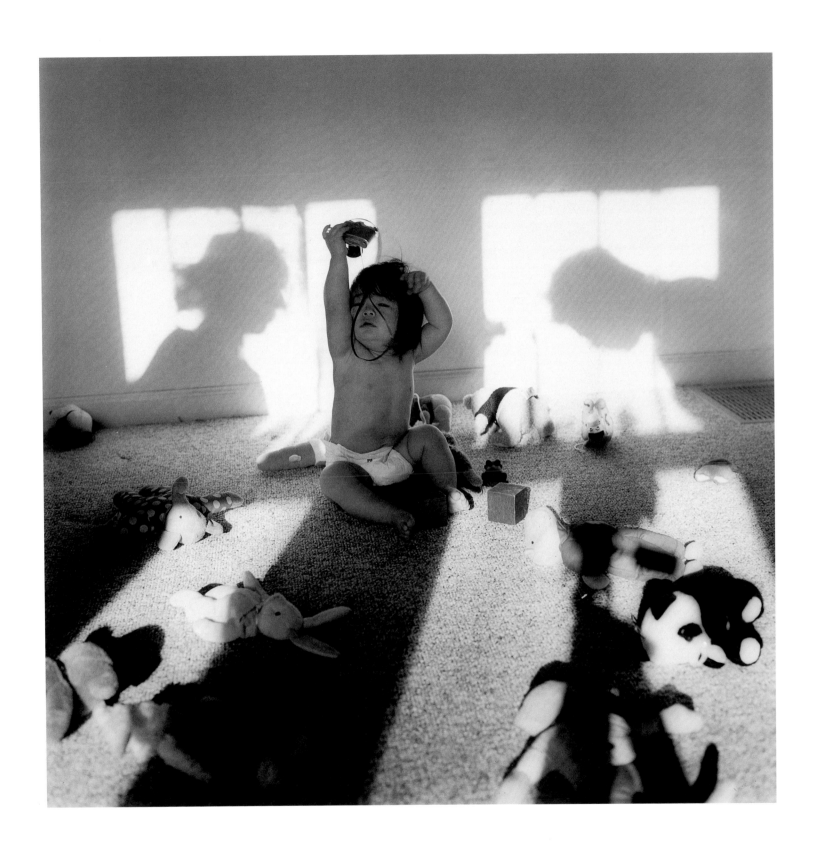

Morning Light, Bloomington, Indiana, Spring, 1999
Silver gelatin print, 14 x 14"

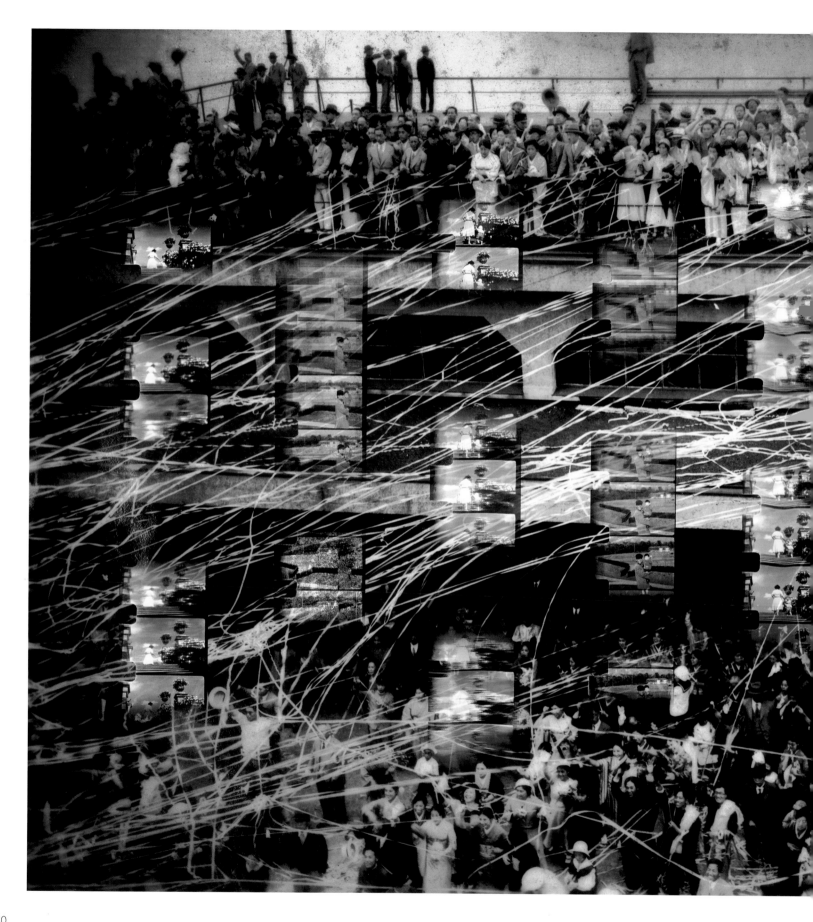

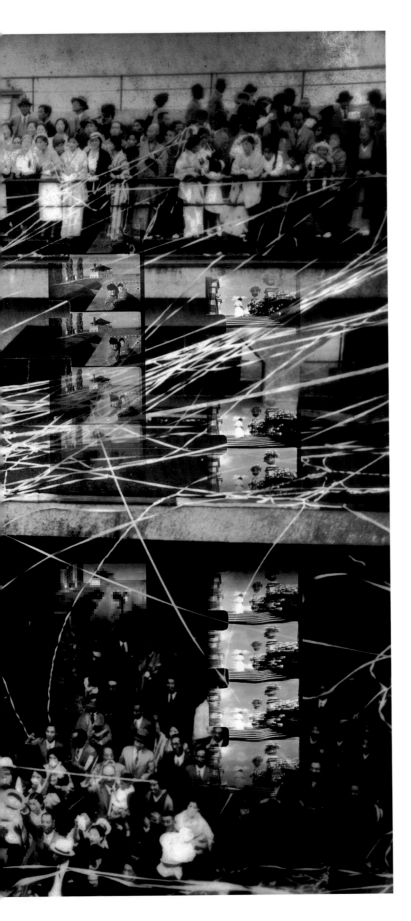

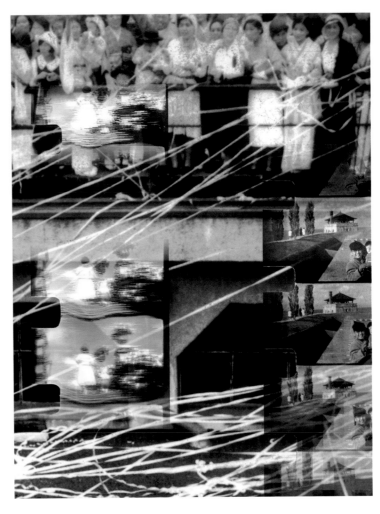

Departure, from the series *Ma-between the past, 2002-2003*
Pigmented inkjet print, 30 × 40"

Doug Muir has an astonishing memory. He can recall a conversation he had in the mid-1950s on a street corner in Syracuse, NY almost as easily as one he had last week. He will remember the four or five friends and acquaintances involved in the conversation, and pepper his recollections with descriptions of the long-gone store they were standing in front of, as well as a few more remembered anecdotes about the neighborhood, the car he might have been driving, the name of his girlfriend, or just about any tangential detail that might cross his mind. When he is in the right mood, these recollections come often and run together in a free form of personal and historical narrative worthy of a stand-up routine on Broadway.

Muir grew up in a working class family in Syracuse in the 1940s and 50s, and along with his brothers Ron and Gary, followed his father in the building trades. He has supported himself and his photography by working for more than forty years as a steamfitter. Since 1967, he has lived in Berkeley and Marin County, CA finding work when he needs it at the massive oil refineries in Richmond, CA. He still has family in Syracuse, and comes back to visit at least once a year.

He participated in our residency program in 1981, and his work was featured in a solo exhibition in our Robert B. Menschel Photography Gallery in 1993. For most of his career, Muir has used a 35mm camera to make color photographs of urban environments across the country, producing impeccably crafted images that direct us to consider the delight of the visual choreography of our environment—and our place in it.

Muir started taking pictures of his family when he was twelve. Over the past several years he has turned his interest to the history of his family, and created installations that include family photographs, furniture, and personal artifacts of the lives and times of his immediate family and friends. Last year, Muir participated in his second residency at Light Work, continuing his work of chronicling his family with snapshots. Photography and memory are closely linked through the snapshot. The snapshot aesthetic not only helped forge an identity for photography as a singular art form, it has made the medium the preserver of memories and important moments for most people in the middle, and on the fringes, of the industrialized world. With the casual snapshots Muir continued to make of his family during his residency, and the more elaborate installations he has created centered around his family, he extends his personal memories out into the world as objects open to universal curiosity. Just as he relies on his memories to make anecdotes about his adolescence come alive, the power of the pictures reproduced here are expressed by their timeless quality of a simpler time recalled. Made one afternoon in the long shadows of autumn in Central New York, the pictures describe a certain place, but they also seem to be lost in time.

All of the pictures reproduced here were made within a few minutes. Unlike most snapshots they aren't recording a special event like a birthday or graduation, but Muir has managed to make each image seem like an important moment to remember. Through careful consideration of the quality of light, the attention to simple and tender gestures, and years of practice, Muir creates icons of youthful innocence and family bonds from the most ordinary of afternoons.

He printed these pictures during his 2002 residency, and until I looked at the date on the back of the pictures, I had not realized that they were taken in 1976. In documenting his family and preserving their collective memories, Muir has described a universal point in time in the life of just about any family, just as much as he has remembered a specific moment in the life of his brother's family.

With the elegant framing of a precise eye and the informed memory of a life recalled in full, Doug Muir has moved back and forth between east and west, but has never left his emotional home of Central New York. Yet, he has managed to allow his family the opportunity to represent the memories we might find in our own family recollections.

JH

Doug Muir lives in Mill Valley, CA, and participated in Light Work's Artist-in-Residence program for the second time in September 2002.

DOUG MUIR

Becky and Max, 1976
Silver gelatin print, 8 × 10"

Becky and Friend, 1976
Silver gelatin print, 8 x 10"

David, 1976
Silver gelatin print, 8 x 10"

Ron with the Kids, 1976
Silver gelatin print, 8 x 10"

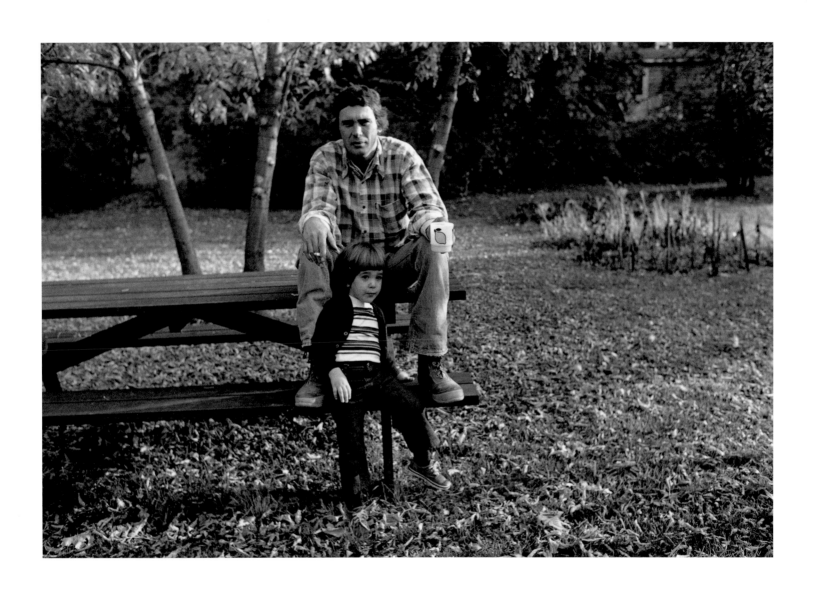

Ron and David, 1976
Silver gelatin print, 8 x 10"

Laura Cano, the second youngest of six Mexican brothers and sisters, knows what it is like to be trampled on. When she was a toddler, her place in the family car was on the passenger side footwell of the car. It was not that her parents were cruel, there just simply was not enough space for eight people in a 1970s Plymouth Valiant.

Being young and happy-go-lucky, the indignity of sitting there never crossed her mind until years later. Looking back now older and wiser, being trampled on appears to be a reoccurring issue in her life, whether the culprits be companies, men, or even her own Mexican government and institutions.

In this series, Cano portrays Eva Bailon de la Cruz, a woman who could very well be a candidate for the most trampled-on woman in all of Mexico. In reality, she is only one of the millions of Mexican women whose lives are filled with sorrowful stories. Eva's life is a catalogue of calamities: unknown father, twice married, twice divorced, four children, death of a child, and loss of an eye through medical ineptness.

Eva is only thirty-two years old, but her torrid experiences in such a short time span have molded her into a woman who, above all, fights for her rights as a woman, as a mother, as a worker, and as a citizen of a country where the hospitals and medical staff have failed her. "They are rights that you have to defend to give them their due worth. It does not matter how strong the enemy is," Eva says, "If you are afraid, you have lost."

Cano admires women like Eva Bailon de la Cruz because although they are downtrodden, they are not defeated. She spent several weeks traveling throughout Mexican cities housing maquilas. Maquilas are assembly factories that assemble and manufacture everything from electronics to clothes. They pay low wages in sweat-shop conditions, and are run by ruthless managers who demand pregnancy tests before they hire women. It is in these cities that Cano met women such as Eva, women desperate to make enough money to feed and clothe their children, thus becoming a laborer in these factories.

Cano met Eva in the border city of Tijuana, and received Eva's permission to photograph her going about her daily duties and chores. During their conversations, Cano was stunned to hear how thousands of "maquila" women work and bring up their families alone. The gaping absence of husbands, boyfriends, or lovers who have fathered children is a void these women have to fill. There is a cultural absence of men. Many Mexican women used to be badly treated by their partners, and now many women, like Eva, have more independence. They end up taking full control of the children and home. Cano says "I've tried to capture images that reflect the force with which they work and fight to change the way in which their mothers lived."

Although Eva is has no material wealth and lives in meager surroundings, an unpainted house with only an outhouse to serve as a restroom, Cano's photographs make it evident that she is a dignified individual. She takes the time to look after her home and her children, as well as herself. Her home is filled with family warmth and happiness, and her children grow up smiling and knowing they are truly loved. In certain portraits, Eva also shows a determination that borders on revenge—perhaps the source of her fighting spirit.

Laura Cano believes the maquilas—aside from their labor exploitations—have given women a new role in Mexican society and industry, partly because of the independence they offer, and the chance to walk away from abusive husbands or partners.

Of her work, Cano says, "It was, and is, important to document the lives of these women. Maquilas have changed the role of the Mexican woman. They are now not just the subordinates of the typical macho male. Now they do double the work, both in the factory and in their homes, but to a certain degree [they are] free."

Chris Aspin

Laura Cano lives in Azcapotzalco, Mexico, and participated in Light Work's Artist-in-Residence program in August 2002.

Chris Aspin lives in Mexico City, and has spent the past ten years living and working as a journalist in Latin America.

LAURA CANO

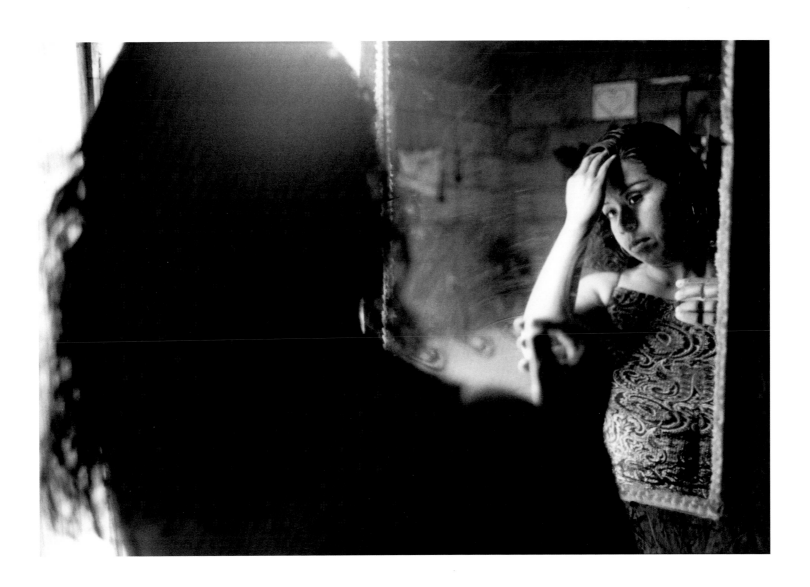

All images are *Untitled*, from the series *Maquilotitlan, Tijuana, Mexico, 2002*
Silver gelatin prints, 12 x 18" each

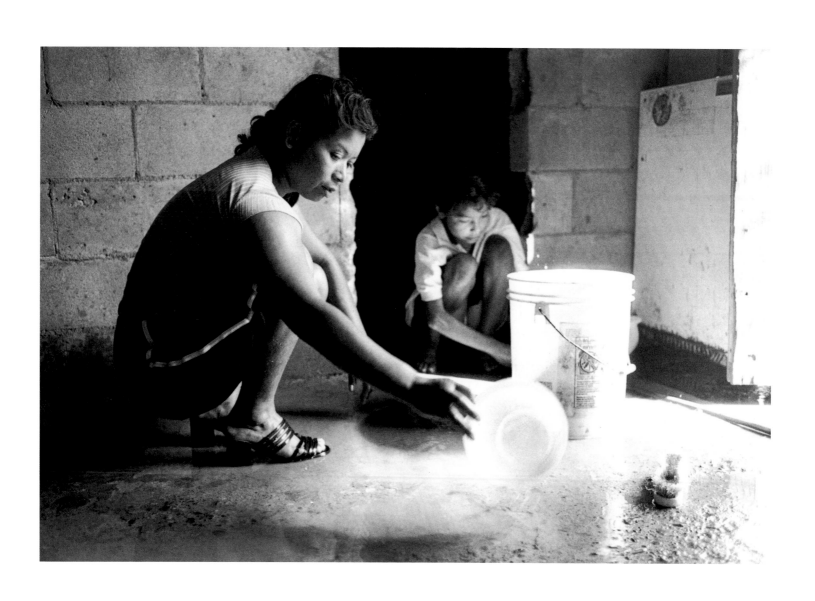

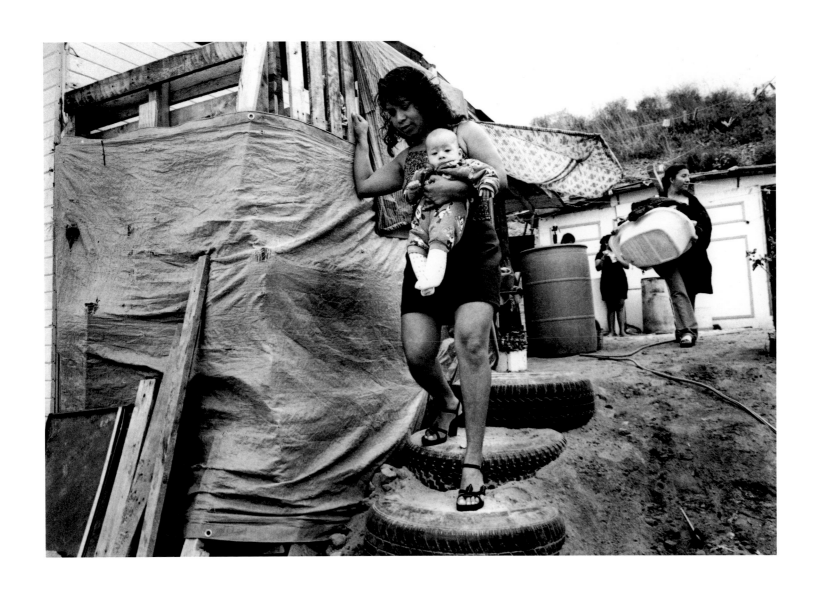

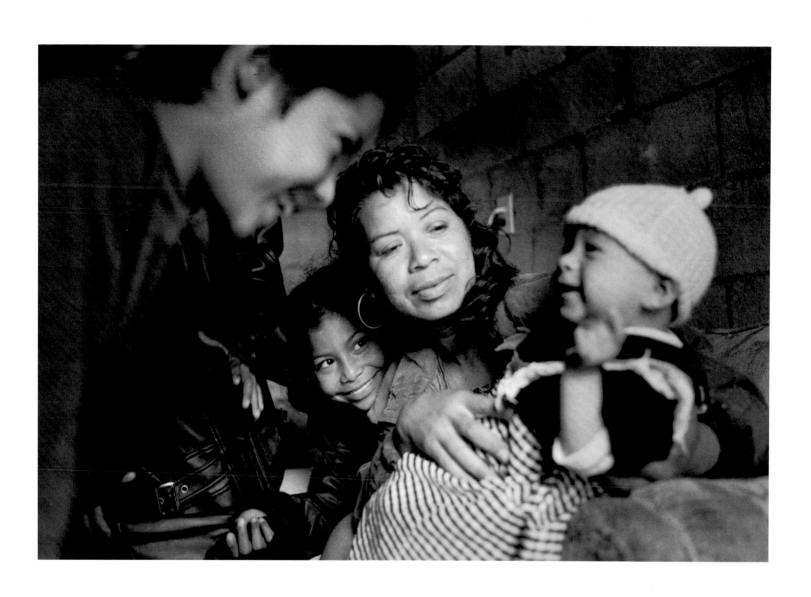

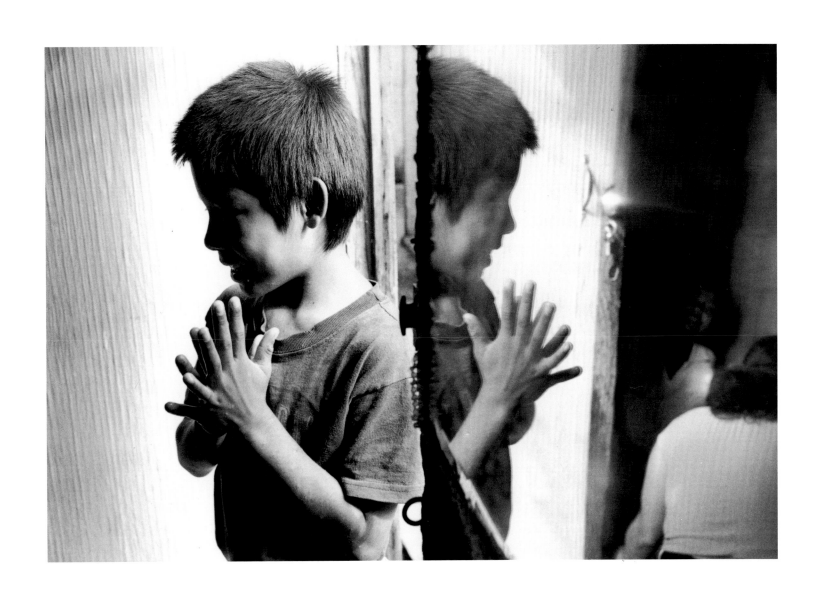

Martin Weber is building a map of all of Latin America, a land rooted in a web of overlapping histories as any other fixed geography, language, or culture. One may say that this map is based on desire. But perhaps desire is the wrong word. These photos are black-and-white stagings of people's wants, wishes, longings, aspirations, and sometimes needs, as well as desire. He calls this growing collection of images his Latin American *Series of Dreams*, and so far, he has trekked through communities in California, Mexico, Cuba, Nicaragua, Argentina, Peru, and along the borders of Bolivia and Uruguay to build this map.

Response to the images in this series is a kind of spellbound discomfiture. The pictures are beautifully constructed, centered on individuals alone, or in groups whose poses simultaneously suggest both extraordinary candor and deliberate theatricality. Although the middle classes are represented here, some of the images portray real poverty. As a viewer from the affluent North, I am struck by the simplicity of so many of these people's dreams, and by the magnitude and sense of urgency these images transmit. They are messages sent from a tormented region of the world where the contradictions of social class are much stronger than in the North, and where during their endless series of dictatorships, uncertainty, fear of speaking, and silence have been normalized.

Weber, who was raised in Buenos Aires, has developed his practice in conversation with the documentary tradition, which has often claimed to present an "objective truth." His pictures, however, are not as straightforward. Early studies in film, theater, and acting have strongly influenced his still photography. He is as interested in the process of making a photograph as much as the result, making reference to the early days of photographic history when sitting for a portrait required stillness and time, making it an event in itself.

Thus, when he began to build this series in 1991, his first intention was to create, through portraiture, the circumstances for a kind of collaboration with his subjects— family, friends, and strangers. He wanted to go beyond the traditional role of the photographer who directs from behind the lens, so he learned to compose and take pictures while standing at a distance from the camera, and to work together with his subjects to compose the shots. Through this he succeeded in making his subjects feel more comfortable,

giving the images a remarkable, candid intensity.

Weber believes that being asked to reflect on what one wants or needs is especially important in Latin America. "It's a kind of metaphor in some ways," he says, "In Latin America we have had to rebuild our societies every ten years. We have so much outside interference in our countries, we have not had a chance to self-determine." He asks his subjects, "If you could be or have anything in the world, what would that be? What do you hope for?" and has them write out their responses on small chalkboards. Weber states that this process of writing out their own "captions" is a chance for these individuals to re-evaluate their situations, and to give small, but concrete form to their dreams at a particular time and place. "Our destiny may only be changed if we allow ourselves to imagine a destiny different from that which we were given," he writes.

In the North, we have been trained to recognize beauty in poverty, being able to view it from a distance. Perhaps we believe the simplicities of poverty are expressive of a greater truth than wealth. There is this appeal to Weber's photographs —they are picturesque and hold a certain authenticity.

In his essay, "In Defense of the Word," the Uruguayan writer Eduardo Galeano explains the way that "mass culture has manipulated consciousness, concealed reality, and stifled the creative imagination in Latin America." Weber's photos defy mass culture, bringing forward, instead, pictures of diverse individuals who have decided to assert for the public, "This is who I am." It is a small act, perhaps, but a liberating one nonetheless, and crucial. More importantly, it is a generous act. It gives us the opportunity, as viewers from far away, to engage with the dreams revealed rather than simply consume them. By revealing themselves, they help us to become aware of who we are.

Jen Budney

Eduardo Galeano, 1983. "In Defense of the Word," *In We Say No.* (New York: W.W. Norton & Company, 1992), pp. 130-142.

Martin Weber divides his time between Buenos Aires and New York, NY. He participated in Light Work's Artist-in-Residence program from April 15 to May 15, 2002.

Jen Budney is a writer and curator living in Ottawa, Canada. For the past two years she has been working as the artistic director of Gallery 101, an artist-run center.

MARTIN WEBER

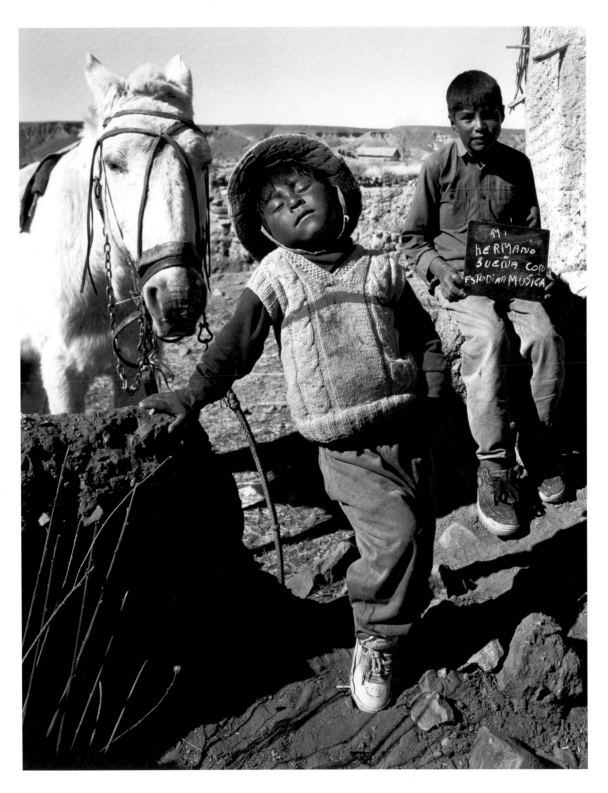

My brother dreams of studying music, Yavi, Argentina, from the project *Series of Dreams*
Toned silver gelatin print, 24 x 20"

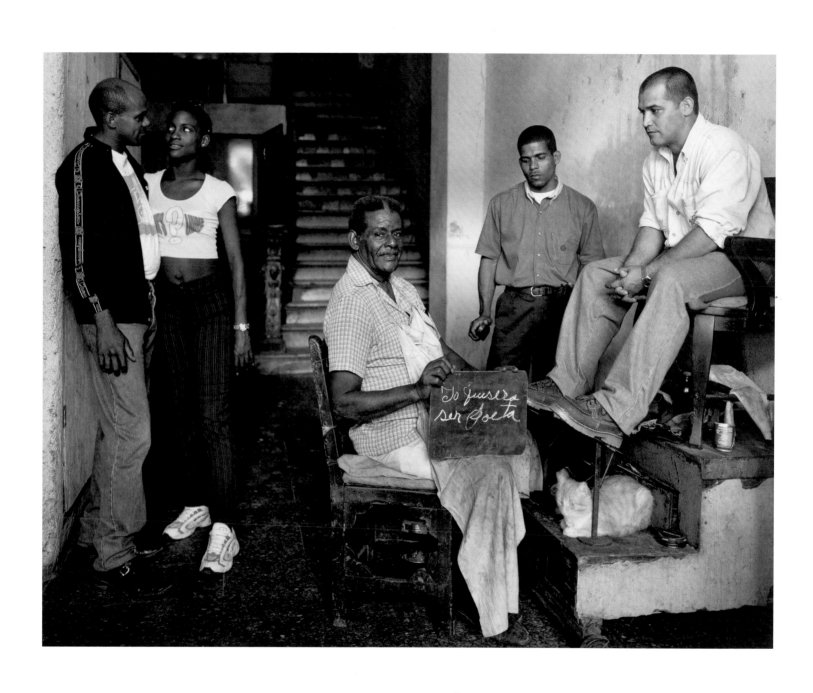

I wish to be a poet, La Habana, Cuba, from the project *Series of Dreams*
Toned silver gelatin print, 20 x 24"

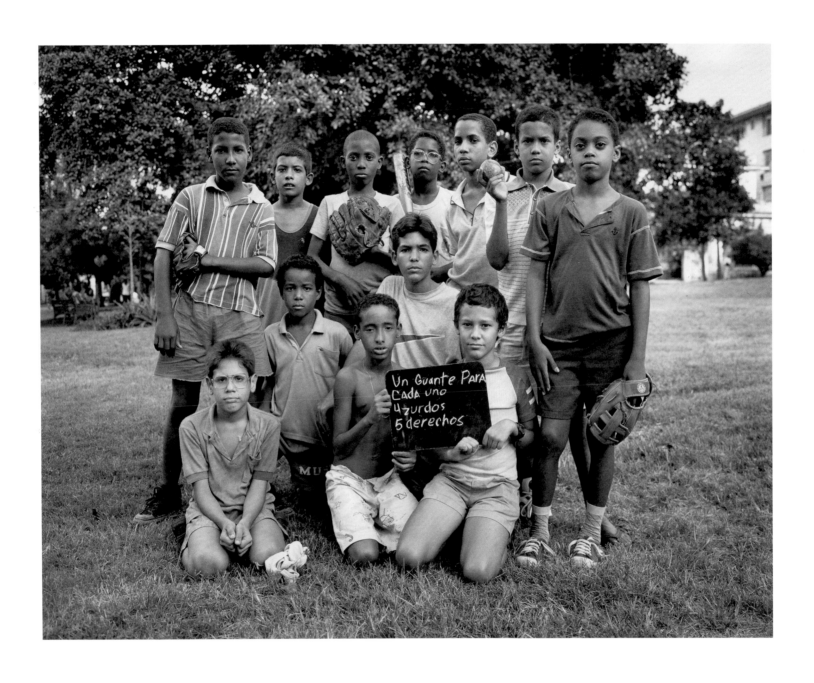

One glove for each, 4 lefties, 5 righties, La Habanai, Cuba, from the project *Series of Dreams*
Toned silver gelatin print, 20 x 24"

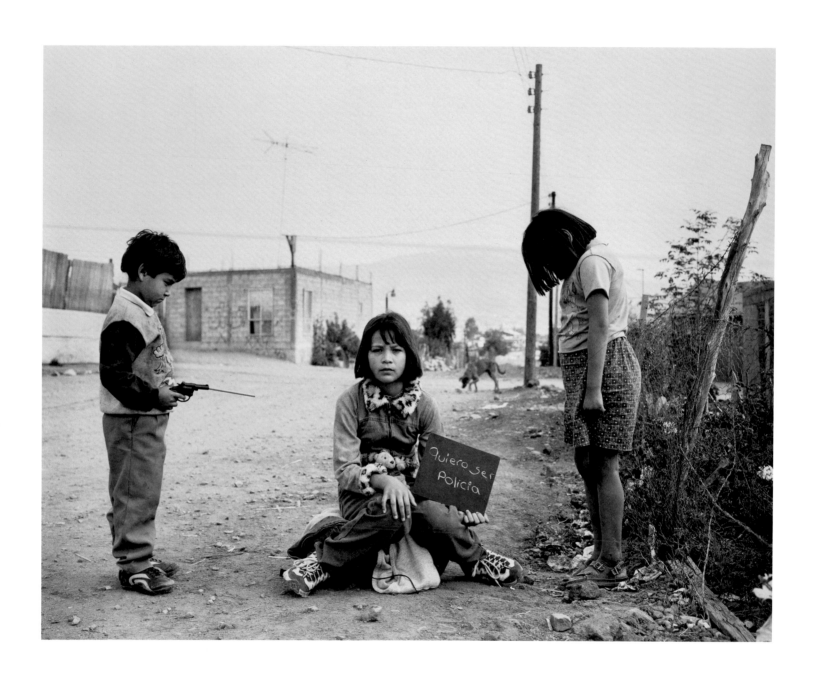

I want to be a policewoman, Maclovio Rojas, Mexico-USA border, from the project *Series of Dreams*
Toned silver gelatin print, 20 x 24"

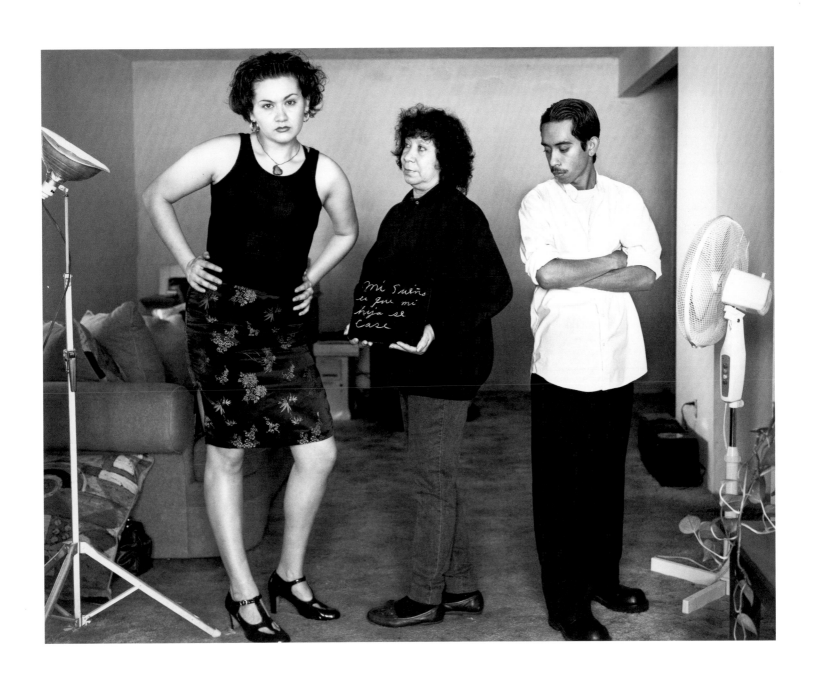

My dream is that my daughter gets married, San Diego, USA, from the project *Series of Dreams*
Toned silver gelatin print, 20 x 24"

For the past twenty-eight years Light Work has been awarding three $1,000 grants every spring to photographers, photo-historians, and critics who reside within a fifty-mile radius of Syracuse, NY, making the Light Work Grant one of the longest running photography fellowships in the United States. While many of the programs at Light Work bring artists from around the world to Syracuse, the Light Work Grant program seeks to provide support and recognition for artists in Central New York. This year, Light Work awarded the twenty-eighth Annual Light Work Grants to Vivian Babuts, Julie Magura, and J.P. Crangle and Chad Reagan.

Since 1995, **Vivian Babuts** (Syracuse) has been photographing avant-garde women performers and the underground, alternative venues in which they perform. Captured in the midst of their performances, these female performers challenge the structure of society and create a context to express their art by experimenting with gender representation. Babuts feels that these women are creating some of the most poignant, smart, and transgressive work in contemporary art today. She states, "These photographs are a rare look at the expression of radical women artists and the space they inhabit. Their work is the avant-garde of today and through these photographs I hope to capture the expressive force of their art and their lives, as well as document this important underground culture."

Babuts earned a BFA, with a concentration in photography, from the University of Michigan, Ann Arbor. Her work has been widely exhibited in many venues including the I Gallery, New York, NY; Leslie-Lohman Gallery, New York, NY; Uzdin Cultural Building, Uzdin, Serbia, Yugoslavia; and WOW Café Theater, New York, NY.

In 1997, **Julie Magura** (Trumansburg) moved to the Finger Lakes region to escape the fast-paced, city life of New York City. Since then, she has been making photographs with an early 1970s Polaroid Land camera. The images in this series are portraits and landscapes of areas within the Finger Lakes region of Ithaca, NY. Over the past five years, Magura created a singular style that combines a snapshot aesthetic with the unique, and often unexpected, results of the Polaroid camera. Of her work she states, "By using only ambient light and documenting people and situations as they occurred, I developed a refinement and gradual understanding of the nature of the camera's aesthetic. The images are valuable in themselves as they are [unable to be reproduced], lacking the traditional silver negative(s)."

Magura received a BFA in documentary photography and printmaking from Rutgers University in 1993. She is actively involved in mentoring youth in the Ithaca community and currently works as a free-lance photographer. She has displayed her work in many group exhibitions including the State of the Art Gallery Juried Photo Show, and State of the Art Gallery Members Invitational, 2002 in Ithaca, NY.

J.P. Crangle and **Chad Reagan** (Syracuse) submitted a collaborative project of prints made from glass negatives Crangle discovered in his mother's attic. Immediately intrigued by the find, Crangle enlisted the help of Reagan to contact print the negatives. Through research and study of the prints, they determined that the negatives dated back to the early 1900s, and could possibly have belonged to a man named Charles Brown. Brown, who appears in many of the images, was a distant relative of Crangle's, being related by marriage to his grandmother. The pair also discovered that Brown died of his own hand, leaving behind a fascinating glimpse into his life and a photographic history of St. Johnsville, NY at the turn of the century. Crangle and Reagan have future plans to create a website for the project, in hopes it will attract more information on the history of St. Johnsville.

J.P. Crangle is an artist, illustrator, and art educator with degrees from Rochester Institute of Technology and Syracuse University.

Chad Reagan is a photographer and filmmaker who studied at Rochester Institute of Technology. He has exhibited his work nationally.

We congratulate the grant winners and wish to thank our three grant selection panelists: Deborah Jack, a photographer and visiting professor at the University at Buffalo, the State University at New York; Julio Grinblatt, a photographer and artist based in New York City; and Sunil Gupta an artist, photographer, and curator in London, UK.

Anisha Joseph

LIGHT WORK GRANT RECIPIENTS

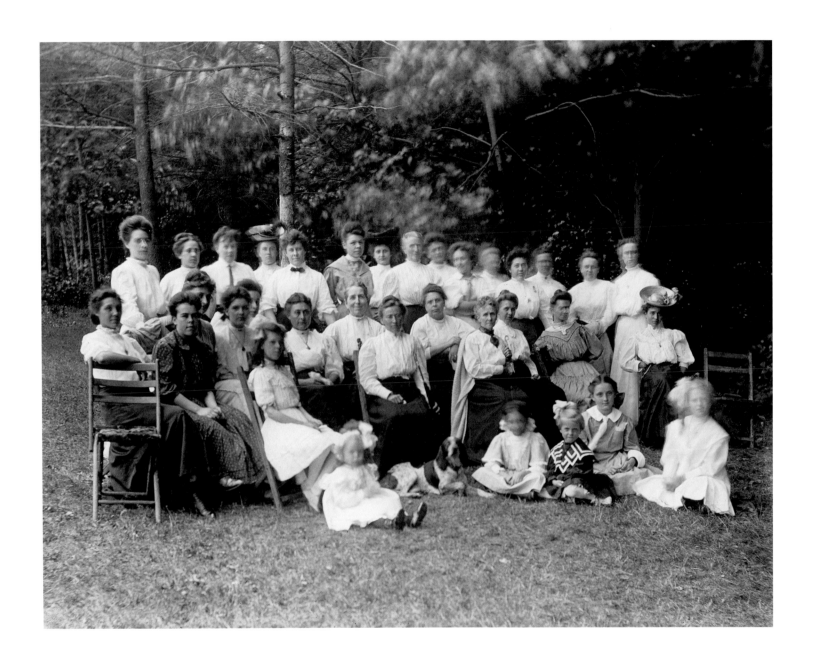

J.P. Crangle and **Chad Reagan**—*Untitled*, from the series *100 Years Later: Photographs by Charles Brown, St. Johnsville, NY, circa 1906*
Silver gelatin print, 16 x 20"

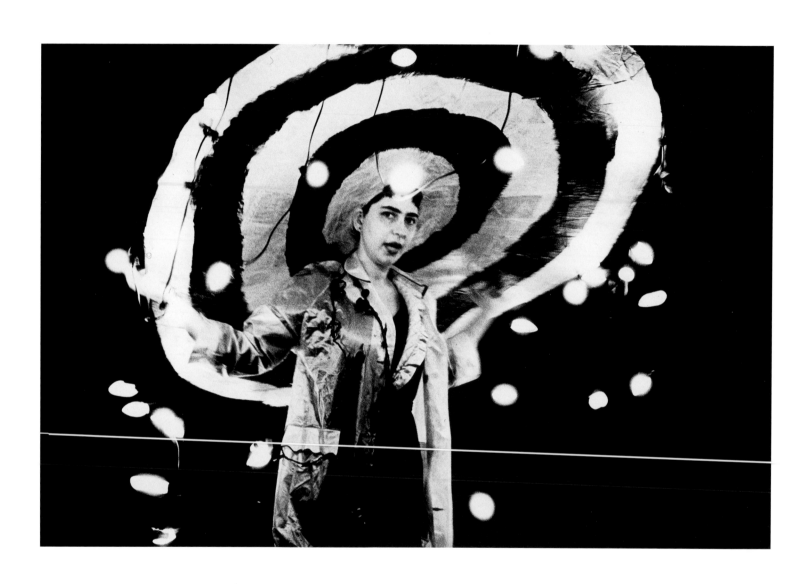

Vivian Babuts—*Performance Artist, Jess Dobkin at P.S. 122, East Village, NYC*
Chromogenic print, 13 x 19"

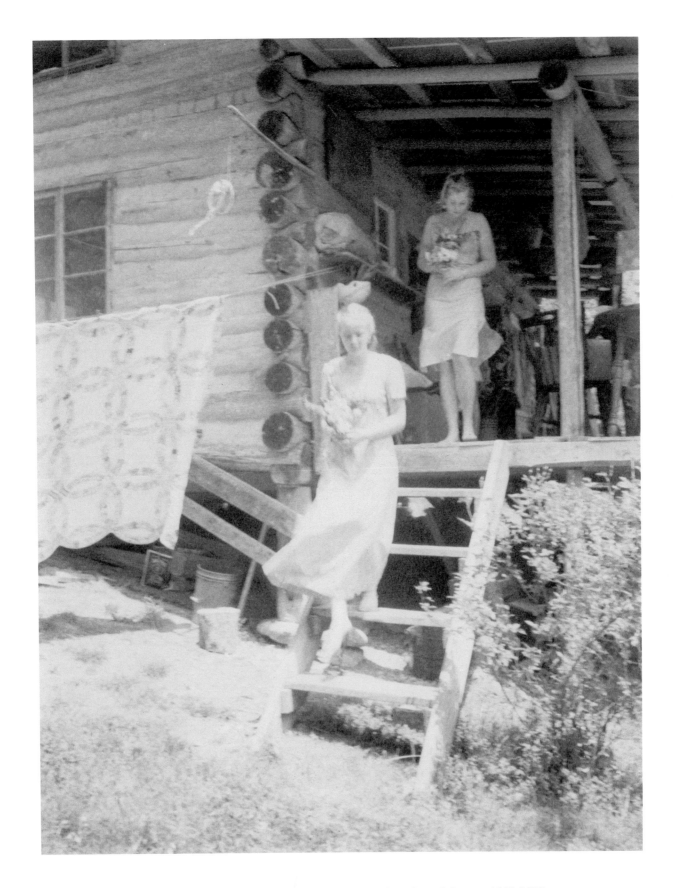

Julie Magura—*Untitled, 2001,* from the series *Past, Passed, Passing, 1998-2002*
Polaroid print, 5 x 3½"

COVER GIRLS

Monica Diana JonBenet Marilyn Jackie Hillary Winona Ryder Jessica Lynch

The Electronic Canvases

Diana, Marilyn, Monica, JonBenet, and *Jackie* are electronic movies, constructed with interior images and maps. Each canvas plays as a looping QuickTime Movie projected onto a wall through a video projector, creating large, moving canvases. When the work was exhibited at Light Work, it was presented on a 42" plasma screen display.

Cover Girls generates a lens to redescribe and a pencil to remap our understandings of how media and its imagery creates the phenomenon we think of as reality. The project creates artwork and adventure that looks beneath the surface of official stories and received histories, and toward the discovery of the social and economic processes that shape the roles and relationships of people and power. The work describes art and its technological processes of production as sites where the legacy of these systems can be unraveled, allowing opposing and multiple positions to form and co-exist.

Each movie transfigures the gestures of the *Cover Girls* in a well-known media clip, through smaller, interior images. The structure of each frame is resignified through an internal code of icons, bringing to the surface an accumulation of buried meanings that constitutes our larger understandings of the role each woman plays on the cover and in the official history defining her. *Marilyn,* in the famous subway grate scene, is recreated in smaller images from the parts of a flower. *Monica* is visualized in the images from the famous tie she gave Clinton, which he wore to the Rose Garden. The labyrinthian icon in the tie historically symbolizes Jason searching for the Golden Fleece, and the four- and five-pointed stars symbolize Aphrodite. *Diana* is bombarded by flash as she walks before the camera. She is recreated through images of landmines from the major conflicts of the twentieth century. *JonBenet* is visualized through Barbie trinkets, and *Jackie* through Warhol's stolen media images of Jackie.

The canvases chart multiple layers of meanings that exist between the life of each woman and the various histories that she shapes. My ambition is to realign our values of description with our sense of understanding. Much of the way the world comes to us in media is through inverted descriptions of what we are really experiencing; questions of truth are enmeshed in questions of fiction.

I propose a photography that will encode values within its structure. I think of the work as a laboratory project, unmooring language, pictures, and rules from historic practices. I believe that testing the practices, photographs make new knowledge more visible and expressible.

I work to unravel and to re-encode our popular images with signs that the world is not just out there a priori, but out there as we construct it, contest it, and remake it.

Patti Ambrogi

Patti Ambrogi is an associate professor of photography at the Rochester Institute of Technology, and the creator of Media Café. She has been the recipient of various grants and awards, including the Eisenhart Award for outstanding teaching.

Cover Girls was presented as part of Light Work's exhibition series in January 2002. Ambrogi participated in Light Work's Artist-in-Residence program in 1991, and for the second time in January 2002 to complete this project.

(right) Stills from *Monica, Marilyn,* and *Jackie,* from the series *Cover Girls, 2002,* computer animation.

PATTI AMBROGI

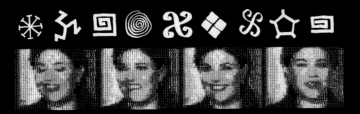

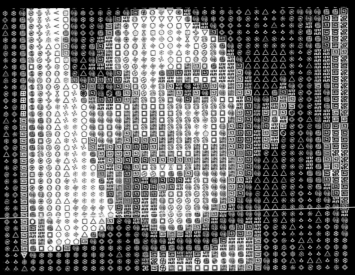

Monica reconfigured in the icons from the tie Clinton wore to the rose garden

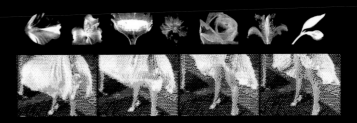

Marilyn reconfigured as parts of the flower

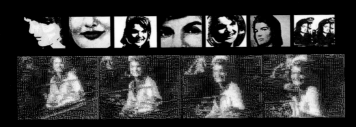

Jackie reconfigured from Warhol's images of Jackie

Trying to categorize the artistic work of John Freyer is not a simple task. He can be considered part story teller, part cultural anthropologist, part photographer, part filmmaker, and part performance artist with an insatiable passion, or perhaps more appropriately, obsession, with the "American Roadscape." Since graduating from college, Freyer's fascination with the open road has sent him, and various accomplices, on numerous trips across the country in search of new encounters and experiences.

On one such journey, using the pretense of seeking out the *best* bacon cheeseburger in the country—purported to exist at the Uptown Grill in Utica, NY—Freyer and two of his friends traveled across the country collecting images, mementos, and stories of their journey. In an effort to share the experiences of this journey, as well his other travels, Freyer produced a series of limited edition books made in collaboration with the other artists and writers he traveled with. In an interview he once said, "I like telling stories often more than once…maybe my friends got so sick of hearing my stories that I had to find a new audience." In 1995, Freyer launched the website <temporama.com> which served as an open repository for past, present, and future projects, as well as an open invitation for others to participate in his ongoing adventures and travels.

In 2000, while attending graduate school at the University of Iowa, Freyer conceived one of his most ambitious projects, *All My Life for Sale*. The project was based on the premise that if one was defined by their possessions, what would happen if they no longer possessed these objects, and how would these objects then alter the lives of their new owners. With the assistance of a group of friends, he systematically tagged and inventoried virtually every object in his apartment. Over the course of the next six months, Freyer turned the selling of his life into an art project on the internet auction site eBay. In most online auctions communication between buyer and seller ceases after the transaction is completed. For Freyer, this is the point where it became interesting. Many of the high bidders provided him with updates on the objects they purchased. "I thought about all of the places my stuff had gone that I had never seen," Freyer states. He was soon mapping out a trip across the county in an attempt to visit the individuals who bought his once cherished possessions. *All My Life for Sale* evolved into a

media sensation with stories appearing in numerous publications including the *London Times*, *New York Times*, and *Newsweek*. Freyer was featured on National Public Radio, *Good Morning America*, and *Late Night with Conan O'Brien*. The project culminated with a book published by Bloomsbury Press and a possible movie deal.

In the course of his travels Freyer began to produce a series of elaborate video animations under the title *motion_pictures*. In this work the artist created several short video loops of particular scenes, and then reassembled these segments to form a completed image, with each segment playing independently of the next. The scenes go from a quiet moment overlooking a field of tulips with Niagara Falls in the background, to a chaotic activity of New York City's Times Square, to a view of Times Square from the New York-New York Casino in Las Vegas, NV, and then back to a view from a park bench along Gilbert Street in downtown Iowa City, IA of cars and pedestrians passing by.

Reproduced here as still images, this animation resembles the photographic assemblages made famous by artist David Hockney in the 1970s and 80s. Hockney perceived a limitation in the photographic image and through this technique of layering multiple images from different vantage points he felt that he was able to expand the perception and possible interpretation of the image. In a similar vein, Freyer allows the viewer to experience these places through multiple perspectives in both space and time. When we consider this work, along with Freyer's other internet based projects, we feel as though we are invited to take part in the journey, to exchange stories, and offer alternate perspectives. As an artist, Freyer creates a point of convergence where multiple points are reconstituted into a single vision mediated through his own idiosyncratic manner of perceiving and disseminating the world around him.

GH

When he is not traveling, John Freyer lives in Iowa City, IA. From 1996 to 1999 Freyer worked as the lab manager for Light Work's Community Darkrooms facility. motion_pictures was exhibited at Light Work from November 1 to December 31, 2002.

(right) Stills from *motion_pictures, 2002*, computer animation.

JOHN FREYER

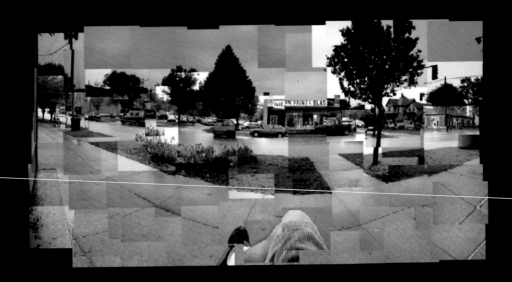

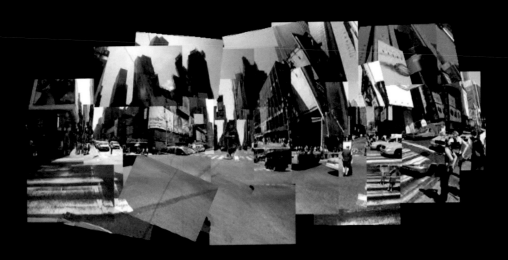

I think about the place of art in black life, connections between the social construction of black identity, the impact of race and class, and the presence in black life of an inarticulate but ever-present visual aesthetic governing our relationship to images, to the process of image making. I return to the snapshot as a starting point to consider the place of the visual in black life—the importance of photography.

bell hooks

We live in a world that magnifies and distorts difference. Skin color, the shape of the eyes, height, weight, age, class, occupation—it is amazing how minute variances spawn divides. What is equally amazing is how a conversation, simple communication, can unearth common threads which resonate with our own familiar.

The images contained in a photograph can stimulate conversation. A photographic image gives us the opportunity to experience the world through someone else's eyes. It invites us into places, times, and allegory where we might never have trod. Once we're in we can become uncomfortable, jolted, quieted, cajoled, even awed.

Finding kinship with another point of view can be an arduous journey. Curating *Ties That Bind: Images of Celebration, Adversity, and Identity* became a group quest to define a relationship, which ultimately had to link images and ideas, at first glance foreign from our own. An extended gaze allowed connections to form.

The connections were rooted in the personal. Kindred struggles, rituals of daily life, place, faith, objects, memory, and ideas from our collective human experience propelled the assemblage of a show resplendent with texture and meaning.

Derived from the work of contemporary photographers from the African diaspora, in the Light Work collection, the images are the work of some of the most celebrated artistic and compelling visionaries of our time who are actively engaged in the field of representation and image making. Carrie Mae Weems, Renee Cox, and Albert Chong are just a few of the photographers present in this exhibition.

Take the journey. Encounter the images. Find the parallels, the harmonies, the dissonance, the document, and the metaphor. Seeing can be both a riveting and binding reality check.

Carol Dandridge Charles, Adjunct Professor
Department of African American Studies
Syracuse University

Ties That Bind was exhibited in Light Work's Robert B. Menschel Photography Gallery from April 19 to December 20, 2002.